Picasso
Guitars

1912–1914

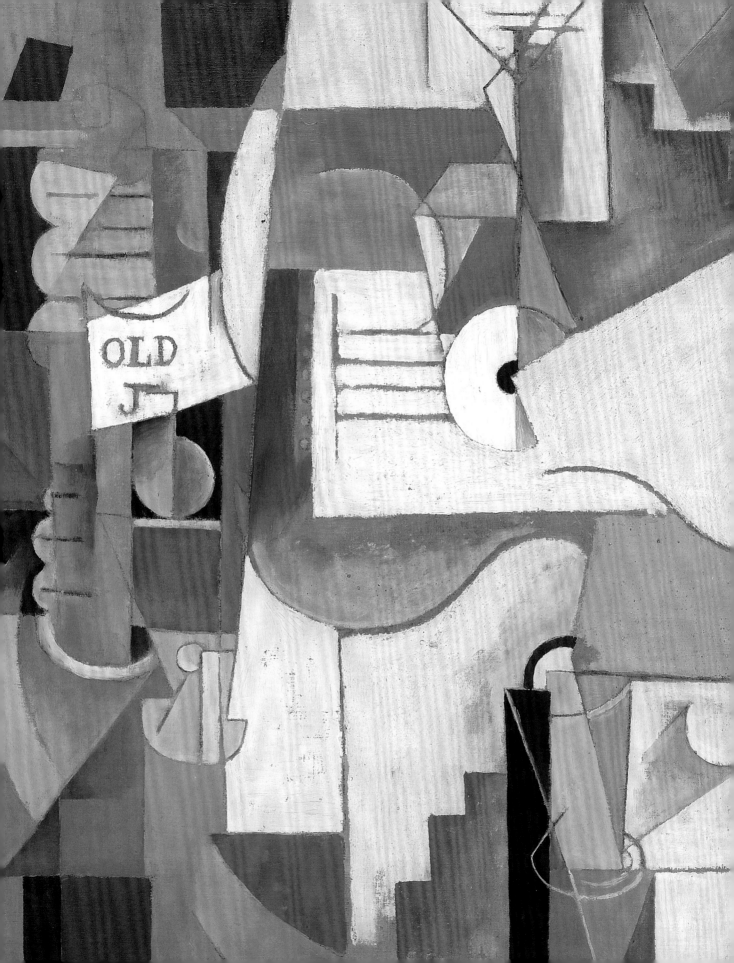

ANNE UMLAND

THE MUSEUM OF MODERN ART
NEW YORK

Picasso
Guitars
1912–1914

Published in conjunction with the
exhibition *Picasso: Guitars 1912–1914*,
organized by Anne Umland, Curator,
with Blair Hartzell, Curatorial Assistant,
Department of Painting and Sculpture,
at The Museum of Modern Art,
New York, February 13–June 6, 2011.

**The exhibition is supported by
Sue and Edgar Wachenheim III.**

Produced by the Department of
Publications, The Museum of Modern
Art, New York

Edited by Rebecca Roberts
Designed by Margaret Bauer,
Washington, D.C.
Production by Marc Sapir

Printed and bound in Hong Kong by
Sing Cheong Printing Company, Ltd.,
on 157 gsm Gold East matte art paper.
Typeset in Mrs. Eaves and Whitney.

Published by
The Museum of Modern Art
11 West 53 Street
New York, New York
10019-5497
www.moma.org

Library of Congress Control Number:
2010937489

ISBN: 978-0-87070-794-0

Distributed in the United States and
Canada by D.A.P/Distributed Art
Publishers, Inc., 155 Sixth Avenue,
2nd floor, New York, New York 10013
www.artbook.com

Distributed outside the United States
and Canada by Thames & Hudson Ltd.,
181 High Holborn, London WC1V 7QX
www.thamesandhudson.com

Illustrations:
Front cover: Still life with *Guitar* (detail;
see plate 79); Still life with *Guitar*
(detail; see plate 80). Front endpaper:
Violin and Guitar (detail; see plate 47).
Frontispiece: *Bottle, Guitar, and Pipe*
(detail; see plate 8). Opposite: Instal-
lation in the artist's studio at 242,
boulevard Raspail (detail; see plate 5).
Page 6: *Bottle, Wineglass, and News-
paper on a Table* (detail; see plate 35).
Page 9: *Head* (detail; see plate 74).
Page 41: *Guitar* (detail; see plate 73).
Page 92: *Guitar* (detail, see plate 3).
Page 97: *Guitar* (detail; see plate 75).
Page 100: *Head of a Man with a Moustache*
(detail; see plate 56). Back endpaper:
Student with a Pipe (detail; see plate 72).
Back cover: *Siphon, Glass, Newspaper,
and Violin* (detail; see plate 26).

Translations are by the authors unless
otherwise noted.

Printed in Hong Kong

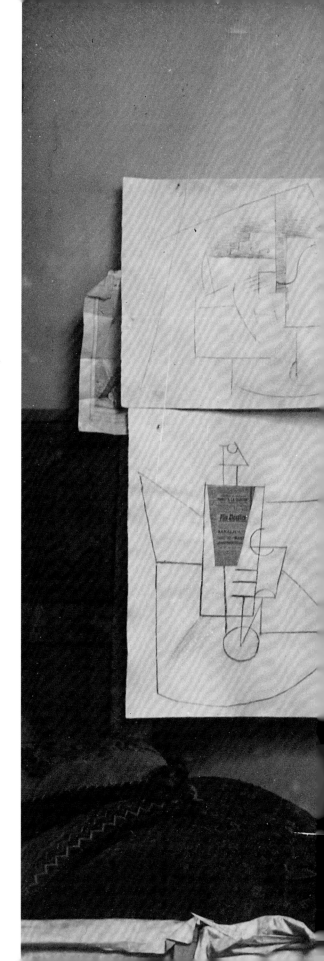

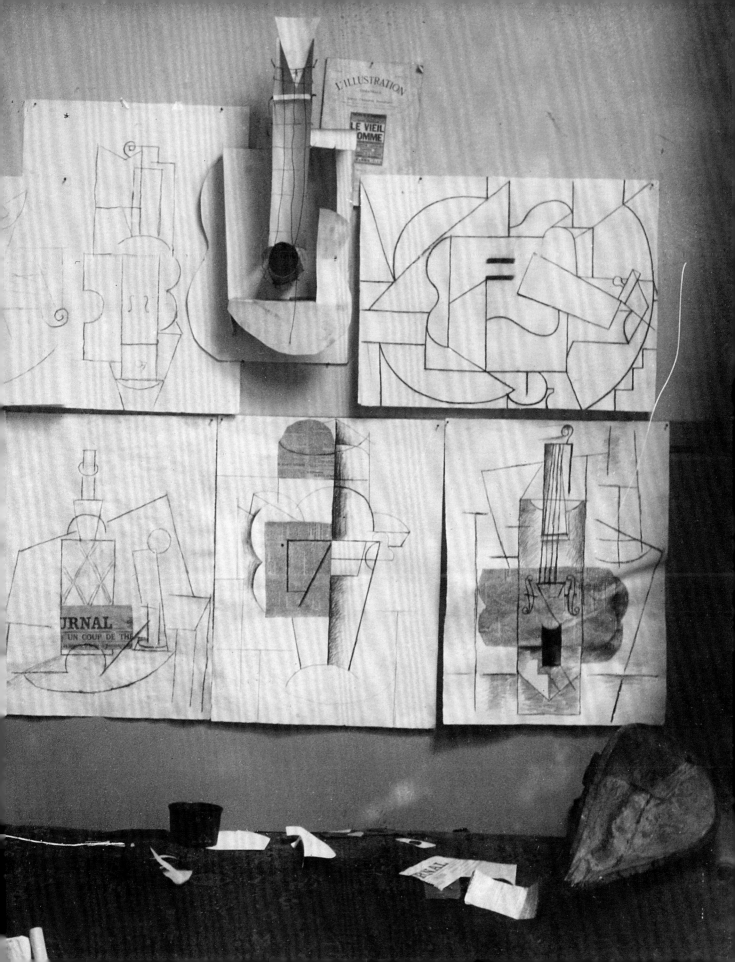

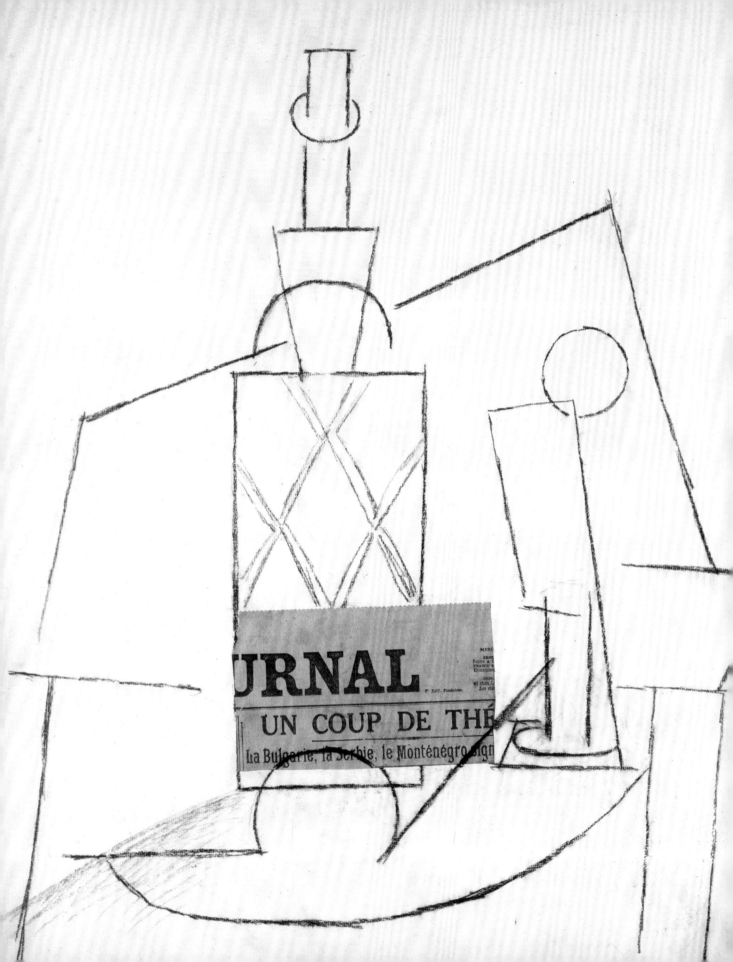

Foreword

This catalogue and the exhibition it introduces extend the long commitment of The Museum of Modern Art to the work of Pablo Picasso and the re-examination of pivotal moments in the history of twentieth-century art. Picasso's cardboard and sheet metal *Guitar* constructions (made in 1912 and 1914, respectively), gifts from the artist to the Museum, were for much of his life known almost exclusively through early photographs and legend. The most widely published of these photographs documents the cardboard *Guitar* in 1913 (plate 79 and cover), surrounded by paper, cardboard, and wood still life elements, all of which were long—and as it turned out, erroneously—presumed lost.

With this black-and-white photograph in mind, art historian and university professor Christine Poggi approached the Museum in December 2005 with a simple, astute question: When Picasso's cardboard *Guitar* arrived here in the 1970s, was anything else packed along with it? Prompted by Poggi's query, Senior Paper Conservator Karl Buchberg recalled that a semicircular piece of cardboard was indeed in Paper Conservation storage. Upon close examination it became clear that this cardboard element, cut from an industrially fabricated box, had two pinholes in it that matched up exactly with two others found behind the sinuously curved face of the cardboard *Guitar*. Guided by the artist's pinholes, the Museum's conservators were able to position *Guitar* and the semicircular piece of cardboard together, uniting the instrument with the tabletop Picasso had made to go beneath it for the first time since he had packed them away together, almost a century ago.

The desire to better understand the significance of this rediscovery and to introduce the recombined still life relief to the public led Anne Umland, Curator in the Department of Painting and Sculpture, to propose an exhibition devoted to the Museum's two *Guitar* constructions and the richly inventive period they frame in Picasso's work. In this she was joined by Blair Hartzell, Curatorial Assistant, an essential partner in the project from the very start. I am grateful to them and to their many colleagues at the Museum for their exceptional contributions to the realization of the exhibition and this publication, which together enrich and complicate our understanding of two iconic objects in the Museum's collection.

On behalf of the staff and trustees of the Museum, I would like to thank the members of the Picasso family for their generosity and enthusiasm, as well as the many private individuals and museums that have supported this exhibition with loans of precious, often fragile, works from their collections. They deserve our profound gratitude. A special debt is owed to those institutions and individuals who made multiple loans.

Finally, the public assembly of such an extraordinary group of works entails considerable costs, and I would like to thank Sue and Edgar Wachenheim III for their kind support and to acknowledge a generous indemnity from the Federal Council on the Arts and the Humanities.

Glenn D. Lowry, Director, The Museum of Modern Art, New York

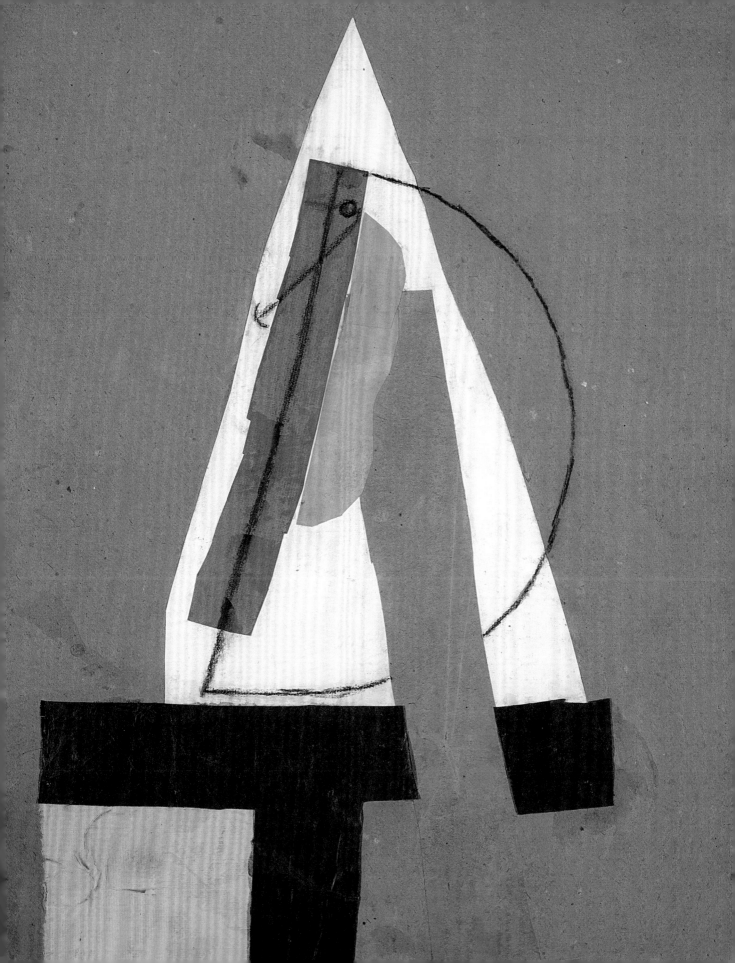

Preface and Acknowledgments

Sometime between October and December 1912, Pablo Picasso made a guitar. Cobbled together from cardboard, paper, string, and wire, materials he cut, folded, threaded, and glued, Picasso's purely visual instrument (plate 11) resembled no sculpture ever seen before. As humble in its subject as in its materials and mode of realization, it irrevocably changed the way we think—not only about what might constitute sculpture but about what can be defined as art. In 1914 the artist reiterated his fragile, papery construction in a more fixed and durable sheet metal form (plate 85). These two *Guitars*—one in cardboard, one in metal— bracket a remarkably brief yet intensely generative period of radical material and structural experimentation. It is this moment in Picasso's work, and the *Guitars'* place within it, that this publication and the exhibition it accompanies set out to explore.

Three photographs that Picasso took, or had taken, of works displayed on the wall of his studio in Paris in December 1912 serve as a point of departure for the exhibition (plates 4–6). These images—which capture details such as a glue pot and paper scraps spread out on a bed, and where the Museum's cardboard *Guitar* construction appears juxtaposed on the wall with three different groups of collages and drawings—introduce Picasso's studio and his process as subjects, captured at a particular creative moment, in a particular time and place. They also invite us to consider, as the artist himself surely did—both within the real lived space of his studio and as photographed—the formal relationships between his three-dimensional card-board *Guitar* construction, the two-dimensional works he placed around it, and, by extension, all the other works that surrounded Picasso's *Guitars* in his studio between late 1912 and 1914.

Because the groupings of works recorded in Picasso's photographs were most likely pinned up and taken down in rapid succession, we did not aim to replicate or re-create these displays. Instead, the exhibition brings together works that fall inside and outside the boundaries of the photographic frame but generally within the chronological parameters established by the two *Guitars*. This affords a rich picture of Picasso's process as he played out and experimented with the possibilities of different materials, mediums, and techniques in an extraordinary cross-pollination of practices.

By focusing on the firsthand experience and sensual apprehension of these closely interrelated works, this exhibition provides an opportunity for new thinking about what is inarguably one of the great moments of twentieth-century art and of Picasso's career. For this reason, the present volume is conceived as an introduction only, to be followed by a digital publication after the exhibition's close. This second volume, which is envisioned to include contributions from Museum curators and conservators and outside scholars, will draw upon the close observation of works assembled on the occasion of the show.

The assistance and collaboration of a great many individuals and institutions have been essential to this project since it was conceived, roughly five years ago. We have been extraordinarily fortunate in the generous help we have received and the goodwill with which it has been given. The thoughtful, enthusiastic support of the artist's heirs has been most keenly appreciated. We extend our sincere thanks to Claude Picasso, Bernard Ruiz-Picasso,

Marina Picasso, and Diana Widmaier Picasso. Christine Pinault of the Picasso Administration, Paris, gave freely of her time and knowledge in countless matters and with unfailing kindness.

Our deepest gratitude must go to the many lenders, both public and private, without whom this exhibition could not have been realized. For essential loans and assistance with research we owe thanks to: Frank Turner, Kevin Repp, Timothy Young, and Moira Fitzgerald, Beinecke Rare Book and Manuscript Library, New Haven, Connecticut; Bruno Racine, Thierry Grillet, Françoise Simeray, and Brigitte Robin-Loiseau, Bibliothèque nationale de France, Paris; Norio Shimada, Yasuhide Shimbata, Tsuyoshi Kaizuka, and Natsuko Tadokoro, Bridgestone Museum of Art, Ishibashi Foundation, Tokyo; Alfred Pacquement, Brigitte Léal, Jonas Storsve, Didier Schulmann, Anne Lemonnier, Anne-Catherine Prud'hom, Gilles Pezzana, Camille Morando, Olga Makhroff, and Marisa De Rosa Minchella, Centre Pompidou, Musée national d'art moderne, Paris; Samuel Keller, Ulf Küster, Fiona Hesse, Markus Gross, Friederike Bühler-Steckling, and Tanja Narr, Fondation Beyeler, Riehen/Basel; Cécile Godefroy and the staff of Fundación Almine y Bernard Ruiz-Picasso para el Arte, Madrid; Bruno Bischofberger, Tobias Mueller, Susanne Daniel, Sven Gehrke, and Silvia Lüdi-Sokalski, Galerie Bischofberger, Zurich; Evelyne Ferlay, Galerie Krugier & Cie, Geneva; Brian Kennedy, T. Barton Thurber, and Cynthia Gilliland, Hood Museum of Art, Dartmouth College, Hanover, New Hampshire; Christoph Becker, Christian Klemm, Tobia Bezzola, Esther Braun-Kalberer, and Jean Rosston, Kunsthaus Zürich; Matthias Frehner, Samuel Vitali, Nathalie Bäschlin, and the Hermann and Margrit Rupf Foundation, Kunstmuseum, Bern; Marion Ackermann, Anette Kruszynski, and Katharina Nettekoven, Kunstsammlung Nordrhein-Westfalen, Düsseldorf; Sophie Lévy and Alexandre Pandazopoulos, LaM Lille métropole musée d'art moderne, d'art contemporain, et d'art brut, Villeneuve d'Ascq, France; William J. Chiego, Lyle Williams, and Heather Lammers, McNay Art Museum, San Antonio; Josef Helfenstein, Bernice Rose, Emily Todd, Jan Burandt, and Judy Kwon, The Menil Collection, Houston; Thomas P. Campbell, Jennifer Russell (who also provided essential support through the early phases of this project as Senior Deputy Director for Exhibitions, Collections, and Programs at The Museum of Modern Art), Gary Tinterow, Rebecca Rabinow, Rachel Mustalish, and Cynthia Iavarone, The Metropolitan Museum of Art, New York; Lars Nittve, Iris Müller-Westermann, and Margareta Helleberg, Moderna Museet, Stockholm; Anne Baldassari, Annabelle Ténèze, Virginie Perdrisot, Evelyne Cohen, and Sylvie Fresnault, Musée national Picasso, Paris; Hartwig Fischer, Tobias Burg, Mario-Andreas von Lüttichau, and Barbara Hütten, Museum Folkwang, Essen, Germany; Kasper König, Julia Friedrich, and Yvonne Garborini, Museum Ludwig, Cologne; Audun Eckhoff, Frode Ernst Haverkamp, and Nils Ohlsen, Nasjonalmuseet for kunst, arkitektur og design, Oslo; Earl A. Powell III, Franklin Kelly, Andrew Robison, Judith Brodie, Kimberly Schenck, and Alicia B. Thomas, National Gallery of Art, Washington, D.C.; E. John Bullard, George Roland, Paul Tarver, and Jennifer Ickes, New Orleans Museum of Art; Timothy Rub, Michael Taylor, Innis Howe Shoemaker, Shelley Langdale, Suzanne Penn, Scott Homolka, Nancy Ash, and Shannon Schuler, Philadelphia Museum of Art; Simon Groom,

Patrick Elliot, and Jacqueline Ridge, Scottish National Gallery of Modern Art, Edinburgh; Sean Rainbird, Ina Conzen, Corinna Höper, and Peter Frei, Staatsgalerie Stuttgart; Kerry Stokes, Erica Persak, and Sarah Yukich, Kerry Stokes Collection, Perth; Clark B. Winter, Jr.; and all those who wish to remain anonymous.

We would also like to thank Tatyana Franck, Florence Half-Wrobel, Emily Braun, Diana Howard, Helene A. Rundell, and Susan L. Shillito for their essential help. Catherine Forni, Hamish Dewar, Fraser Marr, and Ivor Kerslake have been remarkably kind and generous with their time and expertise. Norbert Nobis, Ria Heine, and Isabel Schulz, the Sprengel Museum, Hannover; Pepe Serra Villalba and Anna Fábregas, Museu Picasso, Barcelona; and Carmina David-Jones, Sofía Díez Ruiz, Maura Verástegui, and Elisa Maldonado Garrido, Museo Picasso, Málaga, all provided very collegial support. Thanks are also due to Alice M. Whelihan, Indemnity Administrator, National Endowment for the Arts.

Essential information and assistance with loans have been provided by many individuals: first and foremost, David Nash, Mitchell-Innes & Nash, New York, who gave his time and expertise with absolute goodwill; Michael Findlay, Acquavella Galleries, New York; Doris Ammann and Christa Meienberg, Thomas Ammann Fine Art AG, Zurich; Arlette Bollag, Bollag Galleries, Zurich; Christopher Burge and Conor Jordan, Christie's, New York; Peter MacGill, Pace/MacGill Gallery, New York; Anne Tucker and Lorraine Stuart, Museum of Fine Arts Houston; and Charles Moffett and Chloe Downe, Sotheby's, New York. Phyllis Hattis has been a most treasured ally and dedicated *complice*, as has Katharina Schmidt.

A project such as this could not have been realized without the indispensible research of past and present scholars. We would like to recognize the very significant foundation furnished by William S. Rubin's 1989 exhibition *Picasso and Braque: Pioneering Cubism* at The Museum of Modern Art; the catalogue published on the occasion of that show, over twenty years ago, including the remarkable work of Judith Cousins; and *Picasso and Braque: A Symposium* of 1992: they have been crucial to every project on Cubism since and most particularly to the present study. For their time, scholarly expertise, and encouragement, we are warmly indebted to Christine Poggi, Elizabeth Cowling, Pierre Daix, Jeffrey Weiss, Pepe Karmel, Hélène Klein, Isabelle Monod-Fontaine, John Richardson, Peter Read, Lewis Kachur, Juan José Lahuerta, Laurence Madeline, and Beth Gersh-Nešić. Mrs. Alexandre P. Rosenberg and Quentin Laurens, Galerie Louise Leiris, Paris, provided gracious support.

We are most grateful for the dedication, creativity, and consummate professionalism of our colleagues within the Museum. Foremost thanks go to Glenn D. Lowry, Director, for his steadfast support. Ann Temkin, The Marie-Josée and Henry Kravis Chief Curator of Painting and Sculpture, has been an enthusiastic and extremely effective advocate and advisor from the very inception of this project, and

for this we are deeply grateful. Ramona Bannayan, Deputy Director for Exhibitions and Collections, has provided crucial guidance. Peter Reed, Senior Deputy Director for Curatorial Affairs, and James L. Gara, Chief Operating Officer, have also extended key support. We are tremendously grateful to Michael Margitich, Senior Deputy Director for External Affairs, and to his staff in the Department of Development: Todd Bishop, Lisa Mantone, Lauren Stakias, Heidi Speckhart, and Claire Huddleston.

In the Department of Exhibitions, Maria DeMarco Beardsley and Jennifer Cohen have guided this project with unwavering good judgment, not to mention good humor. The advice and insight of Patty Lipshutz and Nancy Adelson in the Office of the General Counsel have been most sincerely appreciated. Diana Pulling and Eliza Ryan in the Office of the Director provided indispensable help with loan-related correspondence. Jay Levenson and Sylvia Renner in International Programs offered kind, timely assistance.

In the Department of Collection Management and Exhibition Registration, we are grateful for the expert planning of Kerry McGinnity; Stefanii Ruta-Atkins, Susan Palamara, Jennifer Wolfe, Cheryl Miller, Brandi Pomfret-Joseph, Jennifer Schauer, and Jeri Moxley and her staff deserve special thanks as well. Coordination of the in-house transportation and installation of works was executed with wonderful efficiency by Sarah Wood, Rob Jung, and Steve West. To the resourceful, thoughtful, and hardworking team of preparators, many of them artists, we offer our profound thanks. The assistance of our colleagues in Special Events, Facilities, Security, and Visitor Services is, as always, critical and warmly appreciated.

It is always a privilege and a tremendous pleasure to collaborate with Jerome Neuner in the Department of Exhibition Design and Production; the carefully planned design for this exhibition owes everything to his inimitable skills. We are also grateful to Michele Arms and Peter Perez for their important contributions. The Department of Education has organized wonderful complementary programming, and we thank Wendy Woon, Pablo Helguera, Beth Harris, Laura Beiles, Sara Bodinson, Stephanie Pau, and Allegra Burnette and her colleagues in the Department of Digital Media, who have all enriched the project with programs, texts, and tours. We were tremendously fortunate to have Melanie Monios, Department of Visitor Services, share her musical knowledge and expertise; and we thank Juliet Kinchin and Russ Titelman for their time in the early planning stages. Special thanks are due to Kim Mitchell and Margaret Doyle, Daniela Stigh, Kim Donica, Paul Jackson, and Marina Isgro in the Department of Communications and Julia Hoffman and August Heffner in the Department of Graphic Design.

The staff of the Museum's Library and Archives assisted with the vast body of Picasso literature as well as institutional records that proved critical to our research;

we are grateful to Milan Hughston, Michelle Elligott, Michelle Harvey, Thomas Grischkowsky, Jonathon Lill, Jennifer Tobias, and Lori Salmon. In the Department of Imaging Services, Erik Landsberg, Robert Kastler, Roberto Rivera, John Wronn, Jonathan Muzikar, and Felicia Wong consistently and with indefatigable good humor worked to provide superior new photography of collection works for this project.

Led by Christopher Hudson, the Department of Publications has provided expert, dedicated work in the preparation of the present volume. Kara Kirk, David Frankel, and Marc Sapir deserve the highest praise for their efforts and advice. The keen eye, incisive comments, and careful attention to meaning provided by Rebecca Roberts improved this catalogue in countless ways; we deeply appreciate her clear thinking and consummate care as an editor. Margaret Bauer produced an elegant and sensitive design that admirably suits the subject; we sincerely thank her for her great efforts. Hannah Kim, Christina Grillo, and Maria Marchen-kova all provided critical support as well. Emily Braun, who brought her extensive knowledge and sharp critical insights to bear on an early draft of the essay, has my deepest gratitude. Astute readers and supportive friends Carolyn Lanchner and Adrian Sudhalter, both former Museum colleagues, have once again offered essential feedback, as did Ken Tisa.

In the Department of Conservation, Jim Coddington, Anny Aviram, Lynda Zycher-man, Karl Buchberg, and Lee Ann Daffner each contributed significantly to this project. We owe thanks as well to Erika Mosier, Ana Martins, and Chris McGlinchey. The expertise of our colleagues in conservation has been nothing short of essential to this project, and our most sincere thanks go to Scott Gerson, a key collaborator and member of our exhibition team. His careful, thought-provoking approach to the complex issues surrounding Picasso's materials and processes during the period explored by the exhibition has shaped this project in countless ways.

The generosity of Connie Butler, The Robert Lehman Foundation Chief Curator of Drawings, and of our colleagues Kathleen Curry, Esther Adler, John Prochilo, and David Moreno in the Department of Drawings has been crucial, and we offer our warmest thanks to them. We enjoyed many fruitful discussions with Deborah Wye, Chief Curator Emerita, Emily Talbot, and Caitlin Condell as they worked on their own Picasso show and catalogue in the Department of Prints and Illustrated Books, and their collegial interest has been most appreciated. Sarah Meister and Marina Chao in the Department of Photography provided keen advice.

Our colleagues in the Department of Painting and Sculpture deserve our heartfelt appreciation. Leah Dickerman, treasured office neighbor, has been unstinting in her warm support; her interest and generously given advice have been sustaining. Cora Rosevear and Carla Bianchi worked with exceptional attentiveness to the issues of loan arrangements. Nora Lawrence provided crucial assistance with provenance research. We would also like to acknowledge the kind help of Doryun Chong, Lilian Tone, Rosa Berland, Lauren Mahony, Eleonore Hugendubel, Masha Chlenova, Paulina Pobocha, Delphine Huisinga, Cara Manes,

and Mattias Herold; John Elderfield, Chief Curator Emeritus of Painting and Sculpture; and former colleagues Anna Swinbourne, Veronica Roberts, Jane Panetta, and, most particularly, Adele Nelson. Rhys Conlon, my former assistant, handled endless details of correspondence, catalogue image procurement, and travel arrangements with warmth and creativity. The project has benefited from the dedicated efforts of interns Vanessa Fusco, Roxanne Matiz, Nicole Benson, and Caroline Stawell. Vérane Tasseau offered key assistance with research in archives and libraries throughout Paris.

I am inexpressibly indebted to those most intimately involved in this exhibition, whom I must single out for their talent and tireless work ethic. Caitlin Kelly, who came to the project when it was already well underway, quickly mastered its complexities of content and procedure. I have relied on her efficiency, enthusiasm, and wonderfully positive attitude. Blair Hartzell, who has worked on this project virtually since its inception, has been a partner in the truest sense. With grace and incisive judgment, she has handled complex administrative and diplomatic responsibilities and, over and above this, contributed excellent research and writing. I have relied on her discerning eye, curatorial judgment, and scholarly insight in every phase of this endeavor; neither exhibition nor catalogue would have been possible without her vital support.

Anne Umland, Curator, Department of Painting and Sculpture

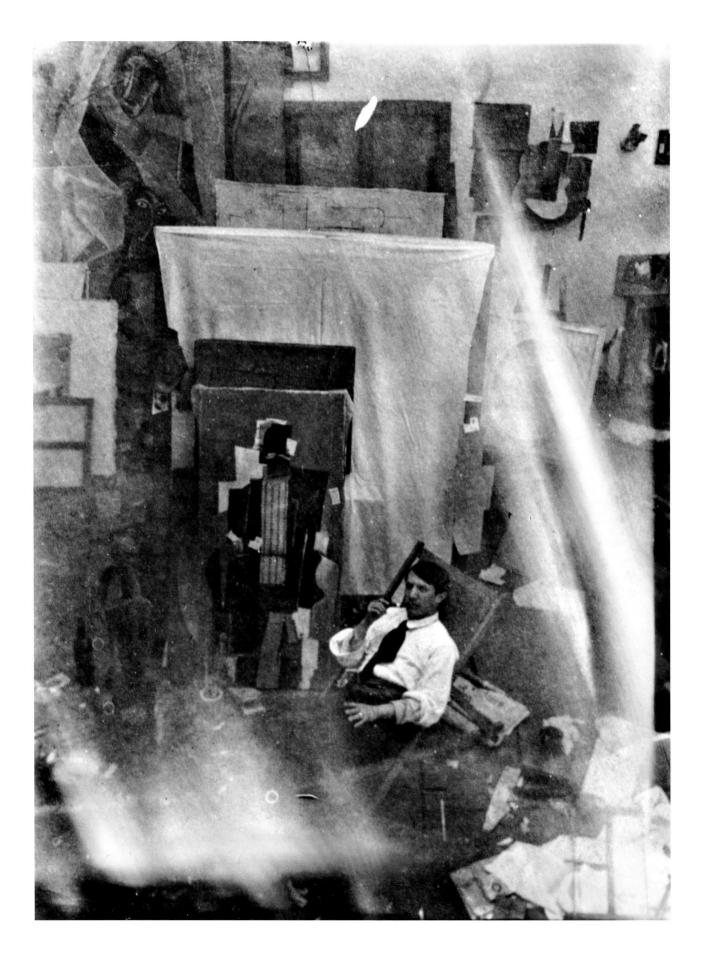

1.

Self-portrait with *The Smoker*. Paris, 1914–16. Gelatin
silver print, 7 ¹⁄₁₆ x 5 ⅛" (18 × 13 cm). Archives Picasso.
Musée national Picasso, Paris

Sometime between 1914 and 1916, Pablo Picasso posed
for a photograph in his Paris studio, in Montparnasse
at 5 *bis*, rue Schoelcher (fig. 1).[1] The camera appears
to have been positioned high above the studio floor,
possibly on a ladder or on the ledge of one of the tall
windows that traversed the studio's northwest facade.
Despite the photograph's fuzzy quality and the streaks
of what is probably bright sunlight that interrupt and
obscure certain of its details, it captures a remarkable
amount of visual information: In the background, at
upper left, the savagely distorted, scarified faces of two
figures in Picasso's notorious painting *Les Demoiselles
d'Avignon*, completed in 1907. In the center, beside
the artist, *The Smoker*, a painting-cum-collage.[2] At lower
right, signs of messy, papery process. Amidst all this,
clearly visible in the photograph's upper right-hand
corner, is Picasso's cardboard *Guitar* construction, a
work that, like *Demoiselles*, announces a crucial rupture
in modern art's history. Its significance, however, is as
different from *Demoiselles'* as its subject, scale, and mode
of realization.

ANNE UMLAND

The Process of Imagining a Guitar

2.

Les Soirées de Paris, no. 18 (November 15, 1913): 12–13.
The Museum of Modern Art Library, New York

Picasso had positioned his cardboard *Guitar* within a still life arrangement whose elements, other than *Guitar* itself and the semicircular cardboard tabletop beneath it, were most likely found rather than executed by the artist's hand. At left, behind the cardboard construction, Picasso pinned up two overlapping sheets of mechanically reproduced faux bois wallpaper, which provided him with a ready-made means of representing a wood-paneled wall.[3] At right he placed a previously folded sheet of paper bearing what appears to be a stenciled image of a bottle of Anis del Mono, a traditional Catalan liqueur, evoking a café scene. Suspended from the tabletop's right corner is a piece of wooden wall molding that doubles as a tassel. Directly beneath the tabletop is a folded piece of paper whose crease projects out from the supporting wall. The rectangular inner body of *Guitar* itself, while

shaped like a box, is not actually made from one; the tabletop is, however, cut from an industrially fabricated box. The overall composition is a pioneering assemblage, a form of art in which disparate things are brought together—some made by the artist and others not—to create a visibly disjunctive whole.

The precise identification of the elements grouped around *Guitar* on Picasso's studio wall is made possible by an earlier photograph of this still life arrangement (plate 79), taken by a professional photographer in the employ of Daniel-Henry Kahnweiler, Picasso's dealer, sometime prior to its publication in the November 15, 1913, issue of the newly relaunched avant-garde journal *Les Soirées de Paris*.[4] It was accompanied by the simple, succinct caption, "*PICASSO NATURE MORTE*" (Picasso Still life) (fig. 2). For those who believed that art, by definition, involved academic

training, skillful craftsmanship, and traditional, durable fine-art materials, Picasso's still lifes proved deeply unsettling. Subscribers to *Soirées de Paris* were, allegedly, scandalized by this unconventional still life and the three other constructions by Picasso published in the same issue.[5] Many of them canceled their subscriptions, suggesting this radical new art's ability to provoke.[6]

The slight variations between the still life construction with *Guitar* as reproduced in *Soirées de Paris* in November 1913 and its later appearance in the rue Schoelcher studio view underscore this arrangement's provisional character. For despite the rue Schoelcher photograph's graininess, it is easy to see that at least two additional paper elements have been introduced at the upper right and lower left of what is otherwise identical to the *Soirées de Paris* composition, evidence of how, when art becomes a matter of cutting, pinning, and positioning independent elements—whether individual shapes within a composition or individual objects, like the cardboard *Guitar* itself—the potential is always present for fixed relationships to become undone.

The earliest known photographs of Picasso's cardboard *Guitar* are a series of three images, most likely taken by the artist in Paris in December 1912 (plates 4–6); these show *Guitar* hung on the wall of Picasso's studio at 242, boulevard Raspail surrounded by three different groups of drawings and papiers collés.[7] Here the cardboard *Guitar* appears as an isolated, relatively autonomous object—not, in other words, part of the still life compositions into which it was subsequently inserted. Its internal structure—the relation of its various component pieces to one another—remains essentially unchanged. The two distinctly different situations in which Picasso placed and photographically documented his cardboard *Guitar*, however, confirm its identity as a repositionable player with various possible roles.

What those roles might be, the specific historical contexts in which they occurred, and the ways in which they are distinct from yet related to those of Picasso's better-known sheet metal *Guitar* construction of 1914 (plate 85) are among the subjects explored in this essay, as is the relationship of the cardboard and sheet metal *Guitars* to the larger body of assemblages, collages, drawings, paintings, and photographs Picasso created during the approximately two years they bracket. The rich exchange between cardboard and metal, photography and sculpture, planar collage and three-dimensional assemblage affords insight into not only the unique characters of the cardboard and sheet metal *Guitars,* but also an incandescently brief period of structural, spatial, and material experimentation that remains foundational, for the artist and for modern and contemporary art.

Prelude

SORGUES, SUMMER 1912

Picasso's good friend and essential artistic collaborator Georges Braque joined him in Sorgues, in the South of France, in late July or early August; there they continued their close working dialogue.[8] Near the end of the season Picasso took a photograph at his villa's front door, recording the paintings he had worked on over the summer (plate 1).[9] Propped up on the doorstep are works that, despite their differences, exemplify the complex spatiality and borderline legibility characteristic of Picasso's Cubist paintings of the previous two years, with multiple overlapping and interlocking transparent planes, difficult-to-decipher subjects, and a sense of ever-shifting density. The two oval paintings that appear above these works (plates 2 and 3) can be seen, even in black-and-white photographic form, to be significantly different from those beneath them. Both titled *Guitar*, they indicate a change in direction,

a shift in formal tactics: clearly contoured shapes, bright colors, and diagrammatic lines predominate. Unlike the congested compositions of the works photographed with them at Sorgues, their appearance suggests that they could be cut into discrete components, following the boundaries established by the edges of their individual planes or by the drawn lines the artist most often applied in charcoal directly onto raw canvas and framed by painted areas on either side.[10]

Papery and Powdery Procedures

PARIS, AUTUMN 1912

On October 9, 1912, back in Paris, Picasso wrote to Braque, who remained in Sorgues, reporting, "I am using your latest papery and powdery procedures. I am in the process of imagining a guitar and I am using a bit of dust against our horrible canvas."[11] His words announce the start of what would become, over the next two years, a period of radical material investigation. They also suggest a new preoccupation, perhaps initiated in Sorgues, with the guitar as a subject, and the instrument begins to proliferate in his work around this time.[12] Its appearance as a subject of particular focus coincides with the introduction of a wide range of unconventional materials, including cardboard, newspaper, wallpaper, sheet music, and sand, and equally unconventional processes, notably collage and construction, into the making of Picasso's works of art. The Museum's cardboard *Guitar* was most likely completed sometime after the October 9 letter and before the December 1912 studio photographs were taken.

Picasso's letter to Braque clearly credits his friend with the invention of what he describes as "your latest papery and powdery procedures," referring to the now-lost paper sculptures Braque is known to have made in Sorgues that summer and probably to his more recent two-dimensional paper collages, along with his practice of mixing sand and other gritty substances into his oil paints.[13] Any number of Picasso's works from this moment forward demonstrate his evident interest in applying particulate matter—"a bit of dust"—to canvas and paper supports (see, for example, plates 8, 9, 21, 23, 29, 33, 40, 43, 46, 47, and 72). And it is almost certain that his cardboard constructions—which, in the case of *Guitar*, at least, are composed of several different card and paper types—were conceived of, or "imagined," with an awareness of Braque's three-dimensional paper works.[14] Picasso had also had the opportunity in September to see some of Braque's other recent "papery" experiments—charcoal drawings with glued pieces of mechanically reproduced faux bois wallpaper, the first paper collages, which are commonly referred to as papiers collés (glued papers)—and perhaps these "procedures" too were among those he had decided to try out for himself.[15]

Coincidentally or not, what is believed to be one of Braque's earliest papiers collés (fig. 3) takes a guitar as its subject and is so similar in composition to a small painting by Picasso believed to date from around this same moment (fig. 4) as to raise the question of what, if any, the relationship between the two works might be. The forthright legibility of Picasso's picture sets it apart from Braque's, offering an early, vivid example of the way Picasso, in the months to come, would align his work with—and differentiate it from—the technical innovations pioneered by his friend. Picasso's painting, *Guitar "J'aime Eva"* (I love Eva), refers to his companion, Eva Gouel, whose presence in the artist's life has frequently been connected by scholars to the emergence of the guitar as a preferred subject in his work.[16]

Picasso did not play an instrument and is said to have had no patience with most types of music.[17] He is, however, known to have liked guitars, popular, nonclassical instruments closely associated in his time

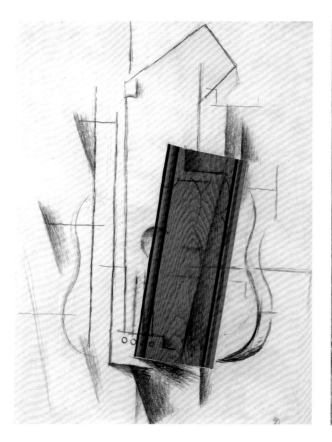

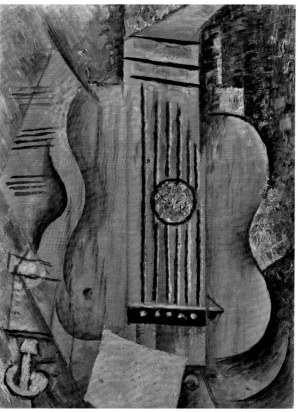

with café life and with flamenco music, a contradictory
genre both primitive and modern, Spanish and gypsy,
fixed and improvisational, with potentially interesting
analogies to Picasso's work.[18] Guitars were, moreover,
closely connected with Spain in the public's imagina-
tion, an association that Picasso could hardly have been
unaware of.[19] Additionally, he may have welcomed the
way the subject of the guitar brought to mind particular
artists and works in modern art's history, notably,
for example, the well-known 1860 painting *The Spanish
Singer*, by the Impressionist master Édouard Manet.[20]
None of these associations, however, can account in
any satisfying way for Picasso's exceptional decision in

5.

Guitar. Sorgues, summer 1912. Ink and pencil on paper, 13 ½ × 8 ¾" (34.3 × 22.2 cm). Musée national Picasso, Paris. Dation Pablo Picasso, 1979

the autumn of 1912 to make a guitar—not just picture it, but construct it—an act that allowed him to discover what, specifically, the guitar had to offer him as a structure, or model, for a particular form of contained spatiality and for a particular vocabulary of simple, separable, iconic signs.[21]

Near the bottom edge of *Guitar "J'aime Eva"* is a small, illusionistically rendered circular element that represents a strap button of the sort usually found on the curved underside of acoustic guitars.[22] This detail is minor yet telling, demonstrating Picasso's basic familiarity with a guitar's structure and constituent parts. So too does a possibly contemporaneous drawing of a guitar where the words "Lopez" and "Madrid" appear faintly penciled across the sound hole (fig. 5), mimicking the way Spanish guitar makers traditionally identify or "sign" their instruments, by pasting labels inside the body of the guitar that are visible through the sound hole.[23]

Both a guitar-maker's label and a guitar strap button are details that can only be seen close up— confirmation, were it needed, that although Picasso did not play a guitar, it was almost certainly an instrument he had handled and touched. Perhaps part of its appeal as an object for Picasso was its easy manipulability, the way it readily lent itself to being grasped, rotated, picked up and set down. Such qualities, of course, hold true for still life subjects in general, a genre that seems at this moment to have become essential for Picasso's art. The hands-on manipulation of objects—many of which, like the guitar, define volumes (other musical instruments, bottles, wineglasses, cups), although they lack its extreme planarity—may have helped to compel a new visual vocabulary that was at once pictorial and sculptural in motivation and affect.[24]

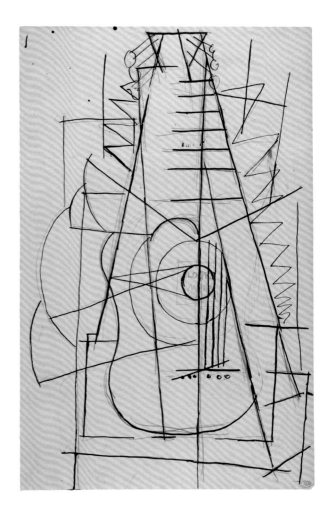

La Bataille s'est engagée

By November 30, 1912, Braque had settled back in Paris for the winter after his time in Sorgues and a short trip to Le Havre to visit his mother; he had either finished or intended to finish a large enough number of papiers collés to merit a separate category on the list of prices agreed to in his contract with Kahnweiler of this date.[25] Shortly thereafter, judging from the dates of the glued pieces of newspaper that in Picasso's first extended series of papiers collés supplant Braque's faux bois, Picasso embarked on his own campaign of cutting and pasting, creating, in what was possibly a period as brief as a few weeks, the series of austere papiers collés and drawings that appear pinned up around the cardboard *Guitar* on his studio wall in the three boulevard Raspail photographs of December of that year.[26]

Although Picasso's *Guitar, Sheet Music, and Glass* (plate 14), which includes at lower left a clipping from the November 18, 1912, issue of the Parisian daily *Le Journal*, is often characterized as his first papier collé—based in part on the date of the newspaper element and in part on the provocative headline *"La Bataille s'est engagé[e]"* (The battle has begun), which has been interpreted in myriad ways and literally refers in truncated form to the First Balkan War—there is no reason to presume that this work was executed any earlier than the December papiers collés.[27] It can, however, be noted that it, along with other collages from this moment (plates 7 and 15), is mounted on a stiff piece of paperboard, establishing a material connection to the *Guitar* construction in addition to the obvious iconographical one.[28]

Of the three other cardboard constructions Picasso made during this period (two smaller *Guitars* and a *Violin* [plates 12, 13, and 84]), the Museum's *Guitar* is the only one whose surface remains bare, unembellished by either pencil drawing, collage elements, or watercolor. This, among other things, left it particularly open to what the Cubist sculptor Henri Laurens later described as the "displacements of light and shadow," the reason why, he went on to say, he always polychromed his own work.[29] Far from seeking to avoid such "displacements," however, the photographs Picasso took (or had taken) of his wall displays in his boulevard Raspail studio in December 1912 seem to demonstrate that he was interested in actively provoking them, using the cardboard *Guitar* in tandem with photography to generate, capture, and arrest the fugitive play of light and shadow on forms.

The fact that the cardboard *Guitar*'s contours consistently remain unobscured by other works in these images suggests, as does the existence of the photographs themselves, that Picasso was intent on seeing his construction in relation to his drawings and papiers collés.[30] Photography's unifying tonalities pictorialize and flatten *Guitar*'s real-life three-dimensionality, setting up an equivalency between it and his two-dimensional drawn and pasted shapes. This allowed him to compare and contrast the "real" shadows in and around *Guitar* with those dark areas he had rapidly created in the surrounding works by gluing down pieces of newspaper and still others generated by the more conventional means of charcoal and pencil shading.

Several of the drawings and papiers collés pictured in Picasso's boulevard Raspail photographs have pinholes in their upper corners or elsewhere along their edges (for example, plates 10, 19, 22, 25, 28, 30, 32, 35, and 38). In some instances, clusters of pinholes are visible, suggesting that the artist may have repeatedly pinned these works up and taken them down, studying them on the wall in relation to the *Guitar* construction (or elsewhere in the studio) and making decisions about when and where to add collage elements cut from copies of *Le Journal*. These cutouts are glued over or pasted within outlines in Picasso's line drawings, taking their place within a predetermined system of relationships,

a point worth underscoring given the undeniable fascination the newspaper clippings hold, with their real-world connections to particular times and places and the instinctive reaction they provoke in any literate viewer to try to read them, even when the artist has made it difficult to do so by positioning the text upside down or sideways.

To focus exclusively on "reading" the newspaper cutouts, as though the text itself always matters, distracts attention from their differential function within Picasso's overall compositions—the way he, for example, repeatedly positioned their ready-made lines and shading in relation to his own handwork and how their cheap, everyday availability contrasts with his chosen fine-art Ingres-paper supports.[31] It is also to ignore the complex and contradictory spatiality of these papiers collés and drawings, which, far from categorically rejecting what the art critic and early Cubist collector Maurice Raynal described in October 1912 as the "little tricks" of naturalistic, academic painting—referring specifically to perspective, trompe l'oeil, and foreshortening—are filled with diagrammatically executed shapes that are inherently perspectival, described by lines that cut into or pop out from the space of his supporting sheets, only to be countered by the literal planarity of the newspaper elements, which in turn, despite their material opacity, dissolve into patterns of dark and light.[32] Even the cardboard *Guitar*, when approached from the side, can be seen to have been subjected to the deformations of perspective—the depth of the right side is greater than that of the left, causing it to project forward, as though acted upon by the literalized conventions of pictorial space.[33]

On or after January 25, 1913, and before he left for Céret in early March, Picasso staged another display for the camera in his boulevard Raspail studio, this time making use of a "real" guitar (plates 48–52).[34] It appears slung over the corner of a large canvas (approximately six-and-a-half feet high) featuring a partially drawn, partially painted figure with newspaper arms.[35] At upper right Picasso suspended another musical instrument, this one of his own making: the painted and constructed *Violin* (plate 84), which closely resembles one of the papiers collés (plate 37) he had photographed with the cardboard *Guitar* on the studio wall in December (plate 5). The drawn elements, such as the lettering at left and the glass at right, both grasped by schematic fingers, mirror the real-life bottle, cup, and newspaper resting on the pedestal table immediately in front of the canvas, and are literally connected to it by the folded newspaper that touches the vertical plane of the picture and the horizontal surface of the tabletop. In this series of photographs, even more explicitly than in the three with the cardboard *Guitar*, Picasso appears deeply engaged by the camera's inherent pictorializing capacity, its ability to effect a collapse between real space and art space, real objects and art objects, and between drawn lines, painted planes, and found or ready-made ones, transforming, in the process, the lived space of the studio into a pictorial stage.[36]

In three of these photographic compositions, a stencil-like Anis del Mono bottle on a rectangular paper sheet is pinned to the wall to the left of the large canvas (plates 48, 50, and 52). It appears to be the very same element incorporated into the still life construction with *Guitar* in the November issue of *Les Soirées de Paris*. *Violin* is also part of a *Soirées de Paris* relief construction (plate 83). In another photograph taken at the boulevard Raspail studio, this one a self-portrait (fig. 6), Picasso posed in front of the large canvas he had used in *Construction with Guitar Player*—disassembled at this point—while off to the right hangs what is almost certainly the mechanically reproduced faux bois paper pictured in the *Soirées de Paris* still life with *Guitar*. Upright on the floor below rests what appears to be a real violin.[37]

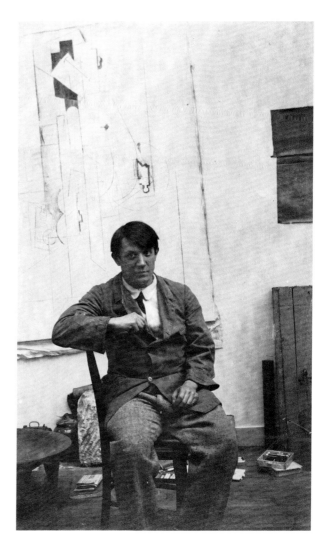

6.

Self-portrait in front of the canvas from *Construction with Guitar Player*. Paris, winter or summer 1913. Gelatin silver print, 6 ⁹⁄₁₆ × 3 ⁵⁄₁₆" (16.7 × 10 cm). Archives Picasso. Musée national Picasso, Paris

Whether the cardboard *Guitar*, its tabletop, and the other elements from the *Soirées de Paris* still life were, in fact, cropped off by the camera in this photograph, or whether the faux bois sheets, like the Anis del Mono bottle, were something that Picasso independently positioned on his studio walls is impossible to know: what does seem clear, based on all these photographs, along with those of the cardboard *Guitar* and Picasso's newspaper papiers collés and drawings, is that various elements from the *Soirées de Paris* relief compositions, the cardboard *Guitar* included, were repeatedly subjected to positioning and repositioning within the space of the studio. As such, Picasso's practice at this moment offers broad parallels with those of artists as different from him as from each other: the Romanian sculptor Constantin Brancusi and the slightly younger Frenchman Marcel Duchamp. All three, working in Paris or its environs in the years immediately preceding World War I, were engaged in practices that led to the redefinition of the art object as something contingent, without a fixed or definitive state, dependent on selection, placement, and combination.[38]

Rose, bleu, jaune, blanc, gris, noir[39]

CÉRET, SPRING–SUMMER 1913

Picasso invited Guillaume Apollinaire and Max Jacob, both poets and critics and frequent visitors to his studio during these years, to dinner on March 6, 1913, at 242, boulevard Raspail, where they may have seen *Construction with Guitar Player* and *Violin* and other recent works by their host.[40] The artist left for Céret, in the South of France, a few days later, where he continued to make collages, drawings, cutouts, and constructions (for example, plates 55, 56, 69–71, and 73–78), many elaborately detailed in a small graph-paper sketchbook (plates 60–68) that likely provided him

with a means of working out ideas and recording even his most ephemeral constructions. The repertoire of materials Picasso used expanded in Céret to include clippings from an 1883 issue of *Le Figaro* (plates 69, 71, and 78) along with brightly colored fine-arts papers and highly decorative wallpapers (plates 73–78), which introduced a new chromatic vibrancy into his work.[41]

Using pins sometimes as well as glue to attach the component parts together, Picasso based some of his new papier collé compositions almost entirely on color. He verged on pure abstraction in several remarkable instances, chief among them *Guitar* (plate 73) and *Head* (plate 74).[42] Considered as a pair, these two papiers collés draw attention to the frequent interchange in Picasso's work between the attributes of guitars and those of human heads. Often, for example, the B-curve of a guitar is positioned to read as the side of a head or an ear (plates 69–72), humorously aligning the organ with which we hear with the shape of an instrument of sound.[43] In still life arrangements (plates 75–77) the curved sides of guitars and the notched profiles of violins are persistently coupled, highlighting how, more often than not, Picasso hybridized his musical instruments.

Two of the relief constructions published in *Les Soirées de Paris* have chronological or material ties to the artist's stay in Céret: *Guitar and Bottle of Bass* (plate 81), with its *Excelsior* clippings of April 23, 1913, and the still life with *Violin* (plate 83), with its distinctly patterned wallpaper, seen in several papiers collés of that spring (including plate 77).[44] Both of these constructions, like the *Soirées de Paris* still life with *Guitar*, have survived in altered or fragmentary form (plates 82 and 84). Comparison of their current states with those captured by

Kahnweiler's professional photographer—for years, the primary way by which Picasso's constructions were known—offers a vivid reminder of all that is lost when works of art are experienced as photographic images as opposed to in three-dimensional reality: Color, for one. A sense of size and relative scale. Material and textural variation. And in the cardboard *Guitar*'s case, in particular, the object's pronounced, physically embodied charge. At the same time, it seems clear that during these years Picasso perceived such differences not in terms of loss, but as a source of revelation and delight. "Yesterday I received the photographs," he wrote to Kahnweiler from Céret on March 21, 1913, "that please me as usual, because I am surprised. I see my paintings differently from how they are."[45]

El guitare

PARIS, WINTER 1913–14

By early October 1913 Picasso and Gouel had moved from the studio on boulevard Raspail to more spacious accommodations just around the corner, at 5 *bis*, rue Schoelcher.[46] Sometime between January 17 and January 21, 1914, Picasso's close friend Gertrude Stein, the American author and collector, brought guests from the Bloomsbury circle of artists and writers, including Vanessa Bell, Roger Fry, and Molly MacCarthy, to pay Picasso a visit.[47] Once back in London, Bell described her memories of Picasso's rue Schoelcher studio in some detail in a letter to her new lover and fellow Bloomsbury painter Duncan Grant:

[It] is large and very light, and has a small room opening out of it with a wonderful view over a great cemetery and an enormous space. The whole studio seemed to be bristling with Picassos. All the bits of wood and frames had become

like his pictures. Some of the newest ones are very lovely I thought. One gets hardly any idea of them from the photographs, which often don't show what is picture and what isn't. They are amazing arrangements of coloured papers and bits of wood which somehow do give me great satisfaction. He wants to carry them out in iron. Roger recommended aluminum, which rather took his fancy. Of course the present things are not at all permanent.[48]

Bell's words are interesting in a number of different ways, particularly her references to the impermanent character of Picasso's recent work, to his desire to realize his "arrangements" in iron, and to the very different impact such works have when seen in person as opposed to in black-and-white photographs. Her description of "amazing arrangements of coloured papers and bits of wood" may refer to Picasso's *Soirées de Paris* relief constructions, among them the still life with the cardboard *Guitar*, which, judging from the rue Schoelcher studio photograph introduced at the beginning of this essay, can be said to have been on view there between 1914 and 1916. The sheet metal *Guitar* must have been executed after Bell's mid-January visit, given her reference to Picasso's wanting "to carry [his arrangements] out in iron" as opposed to any mention of having seen such works.[49]

The first published eyewitness account of Picasso's sheet metal *Guitar* comes from poet, critic, novelist, and vivid anecdotalist André Salmon. It appears in the last chapter of his book *La Jeune Sculpture française*, first published in 1919 although said to have been based on a manuscript completed five years earlier, sometime in 1914.[50] Unlike Bell's letter to Grant, which offers a matter-of-fact, albeit richly evocative description of things she had seen, written from one artist to another,

Salmon's considerable skills as a storyteller turn his own visit to Picasso's studio into a far more dramatic event:

I have seen what no man has seen before. When Pablo Picasso, leaving aside painting for a moment, was constructing this immense guitar out of sheet metal whose plans could be dispatched to any ignoramus in the universe who could put it together as well as him, I saw Picasso's studio, and this studio, more incredible than Faust's laboratory, this studio which, according to some, contained no works of art, in the old sense, was furnished with the newest of objects. . . . Some witnesses, already shocked by the things that they saw covering the walls, and that they refused to call paintings because they were made of oilcloth, wrapping paper, and newspaper, said, pointing a haughty finger at the object of Picasso's clever pains: "What is it? Does it rest on a pedestal? Does it hang on a wall? What is it, painting or sculpture?" Picasso, dressed in the blue of Parisian artisans, responded in his finest Andalusian voice: "It's nothing, it's *el guitare*!" And there you are! The watertight compartments are demolished. We are delivered from painting and sculpture, which already have been liberated from the idiotic tyranny of genres. It is neither this nor that. It is nothing. It's *el guitare*![51]

His words wrote the sheet metal *Guitar* into history, although images of the object remained unpublished for several more decades.[52] Prior to the late 1960s, in fact, it was the cardboard *Guitar*, as part of the *Soirées de Paris* still life composition, that was the far more frequently reproduced of the two works, albeit only in ghostly black-and-white photographic form and sometimes with its medium misidentified as sheet metal.[53] The earliest photograph located to date of the sheet metal version, published here for the first time, shows it installed circa 1923–24 in Picasso's apartment at 23, rue La Boëtie, where the artist had moved with his new wife, Olga, just before Christmas 1918 (fig. 7).[54]

7.

Olga Picasso in the home she shared with the artist
at 23, rue La Boëtie, with the sheet metal *Guitar* at upper
left. Paris, c. 1923–24. Photographer unknown. Modern
print from original negative. Archives Olga Ruiz-Picasso.
Courtesy Fundación Almine y Bernard Ruiz-Picasso
para el Arte, Madrid

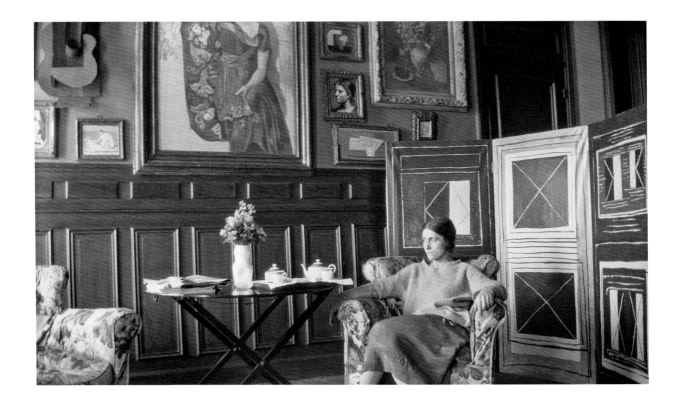

Picasso's Gift of the Sheet Metal *Guitar*

Picasso remained unwilling for many years to allow his sculptures, including his first constructions of 1912 through 1914, to leave his studio.[55] Curator, collector, and Tate Gallery trustee Roland Penrose, unsuccessful in persuading the artist to allow his personal collection of sculptures to travel to London for the Arts Council of Great Britain's Picasso retrospective in 1960, proposed to him in 1963 a show devoted to sculpture to be presented in London in 1966. Picasso replied with a tentative maybe and Penrose then joined forces with Alfred H. Barr, Jr., founding director of The Museum of Modern Art, to organize a sculpture exhibition for two continents.[56] Their plans were nearly thwarted by the announcement of a massive retrospective honoring the artist for his eighty-fifth birthday, at both the Grand Palais and Petit Palais in Paris and encompassing work in all mediums; ultimately, *Hommage à Pablo Picasso*, organized by Jean Leymarie, helped Penrose and Barr secure the sculptures they wanted. Once Picasso had sent the objects he had never before parted with to Paris, he found it easier to let them go on to London and then New York.[57] It was within the context of this series of landmark exhibitions, which introduced Picasso's considerable achievement as a sculptor to a broader audience, that the sheet metal *Guitar* made its first public appearance.[58]

Barr visited the exhibition at the Petit Palais on January 3, 1967.[59] He wrote soon thereafter to Kahnweiler, inquiring about the availability of a carefully selected group of Picasso's constructions and sculptures on behalf of an unnamed collector (Nelson A. Rockefeller, whom Barr advised with respect to his collection).[60] The sheet metal *Guitar* appeared at the very top of Barr's list. Picasso, however, proved unwilling to part with it or with any of his sculptures.[61] Later that same year, the presentation of *The Sculpture*

of Picasso at the Museum further fueled the determination of Barr (then retired), René d'Harnoncourt (the Museum's director, who also undertook the design and installation of the show), William S. Rubin (a new staff member), and the Museum's trustees to acquire the sheet metal *Guitar*. The artist again said no.[62]

An irreverent letter, written to Barr on July 15, 1969, by a grumpy James Thrall Soby (Museum trustee and former chairman of the Committee on the Museum Collections), provides a humorous status report:

> To add to my irascible gloom, Bill Rubin's secretary 'phoned to say she heard I was going to Moulins [*sic*] with Bill to try to wheedle some sculptures out of Picasso.... I didn't have time to add that René [d'Harnoncourt] could probably have swung the job because his size was so big as to make Picasso feel normal and not small and because René was so skillful at this sort of thing. I think the only other person who could get anywhere is yourself. I think Bill [Rubin] would talk too much and walk right into a massacre.... I wish the insurgents could get it through their heads that we're not dealing with the ab-ex boys here, but with a full-grown, indeed aging giant.[63]

Far from provoking a massacre, it was Rubin, presumably one of the "insurgents" and certainly one with a keen interest in Abstract Expressionism, who finally succeeded in "wheedl[ing] some sculptures out of Picasso" where earlier attempts had failed.

When Rubin first met Picasso and his wife, Jacqueline, at the artist's home—Notre-Dame-de-Vie, in Mougins, in the South of France—in early February 1971, the artist was eighty-nine years old and Rubin forty-five years his junior. Rubin later recalled with affectionate humor that Picasso insisted on referring to him as a "young boy."[64] No doubt the "young boy's" ability to speak with conviction about the immense importance Picasso's constructions held for several generations of American artists played a role in the old guitar maker's change of heart. By Monday, February 8, when Rubin visited Picasso again, "no" had not

8.

Picasso and William S. Rubin with the sheet metal *Guitar*. Notre-Dame-de-Vie, Mougins, France, February 8, 1971. Photograph by Jacqueline Picasso. The Museum of Modern Art Archives, New York

9.

The cardboard and sheet metal *Guitars* installed in *Pablo Picasso: A Retrospective*. The Museum of Modern Art, New York, May 22–September 16, 1980. The Museum of Modern Art Archives, New York

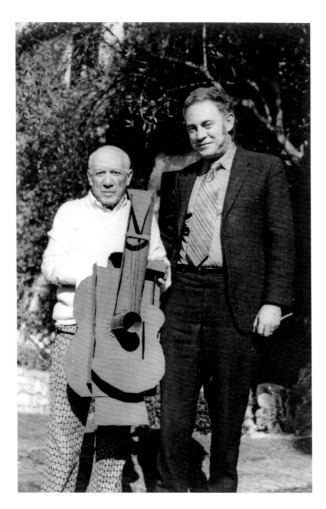

only become "yes," but the artist had decided to give the sheet metal *Guitar* to the Museum as an outright gift (fig. 8).[65] Perhaps relevant to the success of Rubin's campaign was his opening gambit, an offer—ultimately declined by the artist—to trade a painting from the Museum collection by Paul Cézanne, whom Picasso revered, for one of his constructions.[66]

Before the week was out, Picasso's gift of the sheet metal *Guitar* to the Museum had become an international media sensation.[67] The *New York Times* featured the story on its front page, and television footage of Rubin and *Guitar* appeared on all the major networks, as Rubin noted in a letter to the artist.[68] A few weeks later, after it had been placed on public view at the Museum, the *Times* ran another story. Echoing remarks made by Rubin in statements to the press, journalist Hilton Kramer commented that up until the present moment Picasso's constructions had been "known mainly through photographs" but nonetheless had "exerted a powerful influence, altering the entire course of sculpture in this century."[69] Now at last, he continued, "we have an example of the thing itself—in fact, *the* example, the work which (according to Picasso himself) was his very first effort at constructed sculpture. It was preceded, to be sure, by a cardboard maquette (still in Picasso's possession), but this was apparently regarded as a 'sketch.' The sheet metal version was the first complete realization of the constructivist ideal."[70] This quotation encapsulates the Museum's initial attitude toward Picasso's cardboard and sheet metal *Guitars*, which itself reflected conventional material hierarchies of the early 1970s, a moment when the idea that metal was more important than paper still held considerable sway.

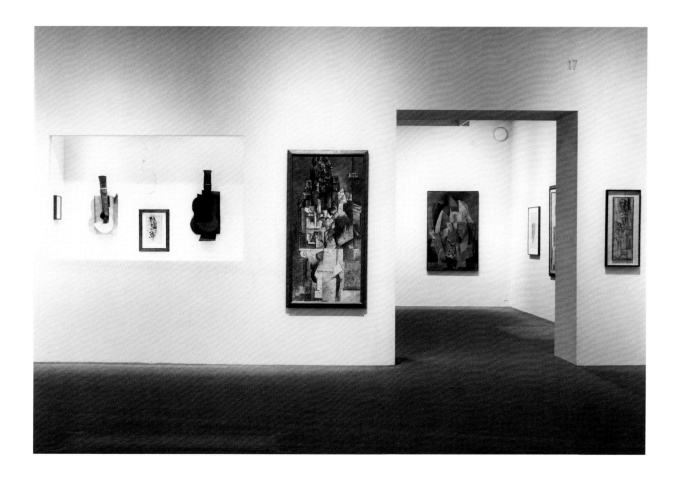

17

Rediscovering the Cardboard Tabletop

The cardboard *Guitar* passed to the Museum, according to the artist's wishes, after his death. The decision to organize the exhibition *Picasso: Guitars 1912–1914* was catalyzed by the discovery, or rather the rediscovery, in 2005 by art historian and professor Christine Poggi that when the cardboard *Guitar* arrived at the Museum in the 1970s, delivered along with it was the semi-circular cardboard tabletop that appears beneath it in the *Soirées de Paris* still life and in the rue Schoelcher studio view.[71] At some point after the rue Schoelcher photograph was taken, most likely around the time Picasso moved out of this studio in 1916, he dismantled his still life arrangement and the cardboard *Guitar* itself. The constituent parts of his unorthodox instrument along with its tabletop were packed, presumably by the artist, in a box from Old England, a Parisian depart-

ment store still in business today at 12, boulevard des Capucines.[72] From then until the early 1970s, when it was acquired by the Museum, and for a number of years thereafter, the cardboard *Guitar* (and the tabletop) remained hidden from view in storage. The other elements of the still life composition—the faux bois wallpaper, stenciled bottle, molding, and folded piece of paper that created a projecting volume under the table—were, according to the artist's recollection in 1971, lost.[73]

Jacqueline Picasso, the artist's widow, transferred possession of the object to Rubin following Picasso's death on April 8, 1973.[74] No mention was made in the news media of the cardboard *Guitar*'s arrival, perhaps most simply because, far from a conventional masterpiece ready for proud display, it arrived at the Museum in six pieces.[75] This compounded the problematic status of what was already considered a secondary, less important work. Rather than being

10.

Pieces of the cardboard *Guitar* prior to reassembly.
The Museum of Modern Art, New York, May 31, 1979.
Photograph by Edward F. Fry. University of Pennsylvania,
Philadelphia. Rare Book & Manuscript Library.
Edward F. Fry Papers

11.

A piece of the cardboard *Guitar* prior to reassembly,
showing pinholes and discoloration. The Museum of
Modern Art, New York, May 31, 1979. Photograph by
Edward F. Fry. University of Pennsylvania, Philadelphia.
Rare Book & Manuscript Library. Edward F. Fry Papers

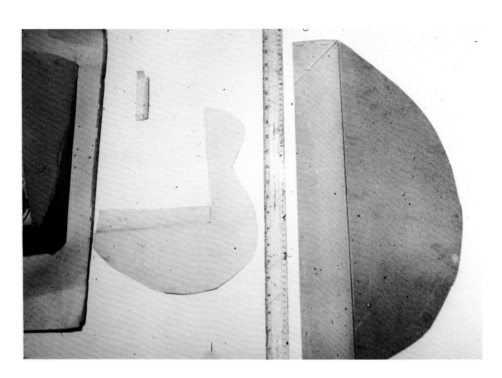

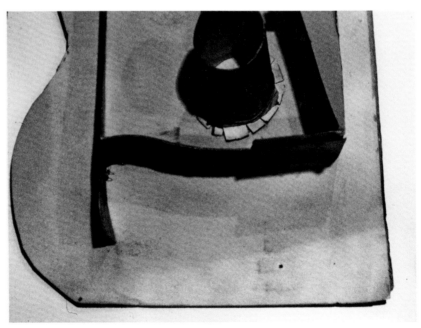

accessioned directly into the Museum's collection, it was, in its fragmented state, assigned to the Study Collection, where it remained for five years.[76] Finally, on the occasion of the monumental Picasso retrospective Rubin organized for the Museum in 1980, conservators put the pieces back together, replacing two strings and the triangular headstock, which had not arrived with the other components. On May 22, 1980, the cardboard *Guitar* went on public view for the very first time, displayed next to its sheet metal partner and accompanied by a label that identified it as *Maquette for Guitar* (fig. 9).

In putting it back together, however, the conservators—almost surely at Rubin's request—left one element unattached: the curved cardboard tabletop. This element can be seen in what are the only known extant photographs of the cardboard *Guitar* in its disassembled state, taken by art historian Edward F. Fry (figs. 10 and 11).[77] The second of these images clearly documents the difference in tone of the portion of the cardboard *Guitar*'s body that had previously been covered by the tabletop, along with two pinholes that match up with two corresponding pinholes on the tabletop, making it possible to position these elements together as Picasso had in the teens. With the tabletop attached, the cardboard *Guitar*'s significance expands from maquette or model for the sheet metal version, rendering it a more independent and complex work (plate 80).[78] To reunite the two elements, using the tabletop to drive a literal, material wedge of difference between it and its sheet metal counterpart, guided by Picasso's pinholes, is to recognize the cardboard *Guitar*'s distinct identity and individual history.[79]

Coda

In 1933 the Surrealist poet and former Dadaist André Breton, who, like Louis Aragon and Tristan Tzara, was among the first after Apollinaire to write about the significance and historical importance of Picasso's papiers collés and constructions, referred to the artist's *Guitars* in terms deeply informed by his Marxist beliefs:[80]

The amazing guitars made of shoddy strips of paper, veritable emergency bridges thrown over the artist's song, have not stood up to the pace of the singer's headlong career. But it almost seems as though Picasso had counted on this impoverishment, this dismemberment even. It is as though, in this unequal struggle, this struggle whose issue is not in doubt, in which the creations of man's hand nevertheless pit themselves against the elements, his aim has been to coax forth, to bring to terms in advance all that is precious, because ultra-real, in the process of their gradual dilapidation.[81]

Breton's words ascribe a type of political intentionality to Picasso's use of "poor" materials that is most likely foreign to the artist's initial motivating impulses in 1912. But his appraisal of the precarious physical state of Picasso's works from those years is accurate. All artworks change over time, of course. Some, however, do so far more perceptibly than others, and there is no question that many of the works in this exhibition display palpable signs of the passage of time: Darkened, brittle newsprint. Foxing. Collage elements flattened by the good intentions of conservators past.

"And as swiftly as a toad's tongue darts," Apollinaire wrote, "Collages were suddenly unglued and glued."[82] These lines appear in *Case d'armons*, a booklet published during World War I on the battlefield, where Apollinaire, like Braque and many others who were close to Picasso in prewar years, was fighting for France.[83] His words capture the fragile, papery, performative character of

the work Picasso made in this period, which the cardboard *Guitar*, with its variant positions and states, can be said to symbolize. At the same time, they suggest, as did Breton's words implicitly, reasons why Picasso chose to memorialize *Guitar* in sheet metal form. Relative to the cardboard version, the sheet metal *Guitar* is a fixed quantity: Stable. Self-contained. Complete unto itself. An ideal creation as opposed to an improvisatory combination that—this is the lesson of the tabletop—remains open to change.

Casting a retrospective glance back in 2007, the American sculptor Richard Serra vividly conveys the way Picasso's *Guitar* offered a historical reference, a point of origin, a tradition for young artists of the 1960s to align themselves with:

Picasso's *Guitar* is a different kind of break altogether, and allows you to understand how space can enter a form and open up volume. At times there are simple moves that disrupt and realign all the arguments. Picasso's *Guitar* brackets casting and modeling as conventions....The *Guitar* is probably one of the most radical moves in sculpture in the entire century. Picasso seems to be actually more inventive in sculpture than in painting. It seems like he has it in his fingertips.[84]

The points Serra makes regarding the construction, however, are structural—they hold true irrespective of the specific physical stuff out of which *Guitar* was made—just as, in a different way, are Salmon's and those of many others who came after him who have written eloquently about the significance of Picasso's *Guitar*.[85] This despite Serra's observation, in the same interview, that "even if the procedure was the same, the material would change both the construction and the readout

of the construction. And once you understood the basic lesson that procedure was dictated by material, you also realized that matter imposed its own form on form."[86]

Admittedly, the procedures and the forms of the cardboard and sheet metal *Guitars* can be described as similar. But the materials are *very* different: In texture. In color. In pliancy. In durability. Serra's words remind us that such differences should be taken seriously, prompting the questions of how and in what ways the "readout" of these works is affected by Picasso's decision to make two distinct *Guitars* and by the cardboard *Guitar*'s variant states. To focus on the material differences between the two constructions is, in the end, to try to better understand and complicate their individual yet interconnected legacies, which mesh two remarkably generative traditions within the history of modern art: One that points toward new definitions of space and structure, which extends from Vladimir Tatlin and other members of the Russian avant-garde to Richard Serra and beyond. Another, first decisively seized upon by the Dadaists, that has to do with found materials and combinatory practices, including assemblage, bricolage, and collage. Each affords artists working today, no less than those of the past century, a vital precedent to look back upon, avail themselves of, react against, and most importantly—in ways that are exciting to contemplate but impossible to predict—continue to creatively combine, supplement, and redefine.[87]

This essay and the exhibition it accompanies are deeply indebted to Christine Poggi, Professor of the History of Art, University of Pennsylvania, for her pioneering research on the topic of Pablo Picasso's *Guitar* constructions and, above all, the insightful questions that prompted this study. See References, p. 101, for a list of her contributions on this topic and p. 31 of this essay for the story of the essential role she played in the rediscovery and rethinking of a long-lost piece of Picasso's 1913 still life with *Guitar* (plate 79).

1. See Baldassari 1994, p. 64, for a discussion of this photograph and the series to which it belongs. Picasso occupied this studio from October 1914 to October 1916; these photographs may date from a single session, c. 1915, during which the artist moved around the studio, striking different poses. This photograph was first published in Cousins and Seckel 1988, p. 569, fig. 7.

2. *The Smoker*. Paris, spring 1914(?). Oil and cut-and-pasted wallpaper on canvas, 54 $^{5}/_{16}$ × 26 $^{3}/_{16}$" (138 x 66.5 cm). Musée national Picasso, Paris. (DR 760). Works by Picasso referenced in this essay that are not included in the plates are identified by an abbreviation of the most relevant catalogue raisonné title followed by the number assigned to the work in that publication. The essential sources cited are Zervos 1932–78 (Z), Daix and Boudaille 1967 (DB), and Daix and Rosselet 1979 (DR). See References, pp. 100–2.

3. The inclusion of the mechanically printed imitation-wood-grain paper is surprising; Picasso's work incorporates almost exclusively hand-painted faux bois, executed on paper or on canvas using traditional artisan's techniques combining freehand brushwork and special graining combs, as taught to him by Georges Braque. See Picasso, letter to Daniel-Henry Kahnweiler, Céret, May 24, 1912, in which the artist asks his dealer to send him tools including stencils for letters and numbers and metal combs for making faux bois, in Monod-Fontaine 1984, pp. 165–66. Braque, in contrast, used mechanically printed imitation-wood-grain wallpaper in his papiers collés of this period; see note 15 below.

4. The original glass plate negatives for this and the three other constructions published in this issue of *Les Soirées de Paris* are held by Galerie Louise Leiris, Paris. Judith Cousins's indispensable chronology of the Cubist years suggests, in brackets, a possible date of October 1913 for this photography session. Cousins 1989, p. 422.

5. The three other constructed works are plates 81 and 83, which exist in altered form as plates 82 and 84, respectively, and a lost work, believed to be destroyed: *Bottle and Guitar*, Paris, 1913 (DR 631). These works were accompanied by one additional plate: *Violin, Wineglass, Pipe, and Anchor*, Paris, spring 1912 (Národní Galerie, Prague; DR 457). This work bears the painted inscription *"Les Soirées de Paris."*

6. Alexandra Parigoris discusses *Les Soirées de Paris* and these photographs in depth, noting how the title *Nature morte* sets up expectations of a known category of art, all the better to dash them. See Parigoris 1988, p. 69. Regarding subscriptions, see Knoedler 1958, n.p., nos. 45–49, and Adéma 1968, p. 232. It should be noted that there were many new subscribers to the journal in this period, chief among them prominent artists and collectors, as well as a long list of authors and critics who received issues gratis.

7. Plates 5 and 6 first appeared in Zervos 1950, pp. 281–82. Plate 4 was first published in Fry 1988, p. 303, fig. 8. Given the consistent perspective across these three photographs, we might infer that they were all taken in a single session, dating from around mid-December 1912, in the interval bracketed by the latest newspaper collage elements used (December 9 or 14) and Picasso's departure from Paris (c. December 21). With thanks to Scott Gerson for his thoughtful comparative study of these studio photographs.

8. No mention of the collaborative exchange and friendship between these artists can be made without directing the reader to *Picasso and Braque: Pioneering Cubism*, presented at The Museum of Modern Art, New York, September 24, 1989–January 16, 1990. See Rubin 1989 and Zelevansky 1992.

9. Braque may have brought Picasso's camera down from Paris, where Picasso had left it. See Picasso, letters to Braque and to Kahnweiler, July 17, 1912, in Cousins 1989, p. 400. For an extended discussion and analysis of this photograph and the works captured in it, see Clark 1999, pp. 169–223. At lower left what may be two additional works are resting on the ground. See Baldassari 1994, p. 203, for discussion and p. 208, fig. 153, for a portrait of Braque, his wife Marcelle, and their dog Turc in front of the same distinctive facade of Picasso's summer rental, Villa des Clochettes.

10. Julio González, with whom Picasso collaborated from 1928 to 1933 on welded sculpture, later explained of these Cubist paintings, "Picasso told me, it would suffice to cut them out—the colors are only the indications of different perspectives, of planes inclined from one side or the other—then assemble them according to the indications given by the color, in order to find oneself in the presence of a 'sculpture.' The vanished painting would hardly be missed. He was so convinced of it that he executed several sculptures with perfect success." González 1936, p. 189.

11. *"Je emploie tes derniers procedes paperistiques et pusiereux. Je suis en train de imaginer une guitare et je emploie un peu de pusiere contre notre orrible toile."* Archives Laurens, Galerie Louise Leiris, Paris. We have maintained Picasso's irregular French orthography throughout this catalogue. See Zervos 1932, p. 23, for the first published mention of this letter (erroneously dated October 7) and Monod-Fontaine 1982, figs. 39 and 40.

12. See Kachur 1993, p. 253, on the proliferation of stringed instruments in 1912, and Rubin 1989, pp. 31–32, for a review of earlier discussions regarding which guitar Picasso's letter refers to. Of course, guitarists appeared in Picasso's work prior to 1912, chief among them the paintings *The Old Guitarist*, Barcelona, late 1903, and Paris, early 1904 (The Art Institute of Chicago; DB IX 34) and *Au Lapin Agile*, Paris, 1905 (The Metropolitan Museum of Art, New York; DB XII 23).

13. See Braque, two letters to Kahnweiler, [August–September] 1912, specifically mentioning *"sculpture en papier"* and *"peinture au sable."* Quoted in Monod-Fontaine 1984, pp. 26–27. No extant photographs document Braque's earliest paper sculpture. The sole documentary photo of such a work dates from on or after February 18, 1914, based on the newspaper visible in the image, and records its installation in the corner of Braque's studio at the Hôtel Roma, 101, rue Caulincourt. Archives Laurens, Galerie Louise Leiris, Paris. Monod-Fontaine 1982, p. 55, fig. 38.

14. For clarity and ease in identifying the two *Guitar* constructions in MoMA's collection, one is referred to in the context of this essay as cardboard and the other as sheet metal. As detailed in the Catalogue, pp. 92–96, it is possible to distinguish between the different materials incorporated into what is broadly termed the "cardboard" *Guitar.*

15. Braque later recounted to the art historian and collector Douglas Cooper his purchase of faux bois wallpaper in early September, from a shop on rue Joseph Vernet in Avignon, while Picasso was away for about two weeks in Paris sorting out his new boulevard Raspail apartment. See Cooper, "Braque as Innovator: The First *Papier Collé*," in Monod-Fontaine 1982, p. 19.

16. During their summer together in Sorgues, Picasso wrote to Kahnweiler that "Marcelle is very sweet, I love her very much and I will write this in my paintings." See Monod-Fontaine 1984, p. 168. As Pierre Cabanne indicated, Picasso soon began calling Eva Gouel by her birth name; before her relationship with him, she had been for some time known by the pseudonym Marcelle Humbert. Cabanne 1992, vol. 1, p. 388. Picasso was deeply saddened by her death on December 14, 1915, as he explained to Gertrude Stein in a letter of January 8, 1916. See Madeline 2008, p. 180. For discussions of guitars, the female form, and Gouel, see Richardson 1996, p. 272, and more generally Spies 1971.

17. Picasso's companion from 1905–12, Fernande Olivier, recorded that the artist did not care for and seemed to know nothing about orchestral music. Olivier 2001, p. 200. Picasso seemed to have little interest in experimental music either, and later admitted that while collaborating with composers Erik Satie and Igor Stravinsky he "had a terrible problem staying awake while their compositions were being performed." Richardson 2007, p. 106.

18. "What he did like was the guitar, guitarists, Spanish dancing and gypsy dancers— everything that reminded him of his own country. . . . Every time he saw them he would marvel at the playing of the guitarists." Olivier 2001, p. 200. This characterization of flamenco is made with thanks to Pedro Romero; see note 19, below.

19. Juan José Lahuerta, in conversation with the author, June 1, 2009, and Lahuerta 1996. See also Romero 2008 on the construction of a national Spanish identity to cloak signs of lumpen culture and the affinities and oppositions to be found between the Situationist International and flamenco. A specifically Catalan association is suggested by Kachur 1993.

20. Édouard Manet (French, 1832–1883). *The Spanish Singer.* 1860. Oil on canvas, 58 × 45" (147.3 × 114.3 cm). The Metropolitan Museum of Art, New York. See Poggi 1992, pp. 79–81.

21. Interestingly, T. J. Clark writes that "Cubist painting is not a language: it just has the look of one. And if it is not a language, then naturally there will not be two native speakers." Clark 1999, p. 223. Rosalind Krauss and Yve-Alain Bois have made the most substantive contributions to the subject of Cubism and the sign; see References, p. 100 and 101.

22. Kahnweiler reported to Pierre Daix, noted Picasso scholar and author with Jean Rosselet of the catalogue raisonné of Picasso's Cubist years, that this painting once had a gingerbread heart inscribed with the words *"J'aime Eva"* glued to its surface just left of center along the composition's lower edge where now a textured rectangle of light paint appears. Under close inspection of the photograph of the earliest documented state, this area seems much more likely to have been executed in paint than in baked goods. See Daix and Rosselet 1979, p. 282 (DR 485), for discussion, and Poggi 1992, p. 37.

23. See Kachur 1993, pp. 258–59, regarding this drawing by Picasso and a related painting, *Guitar and Glasses (Banjo and Glasses)* (1912), by Juan Gris.

24. See Clark 1999, p. 427 n 36, for a parallel discussion of portraiture, around 1910, as "a necessary mode for Picasso's art."

25. Monod-Fontaine 1982, pp. 56–58, figs. 41, 42.

26. Several generations of Cubist scholars have identified fragments of newspaper in Picasso's Cubist works. The present study is most indebted to Fry 1988, Appendix II, p. 310, which usefully notes the date, type, and page from which each piece of newspaper was taken. See Baldassari 2000, pp. 65–71, regarding the studio photographs of probably mid-December 1912, and Weiss 2003 for an exemplary discussion of Picasso's photography.

27. See discussion in Zelevansky 1992, pp. 153, 161–62. The matching half of the November 18, 1912, *Le Journal* front page lies on the bed in plate 5, a photograph that dates from on or after December 9, 1912, based on the pasted newspaper incorporated into completed works hanging on the wall. See Baldassari 2000, p. 71.

28. These works were entered consecutively into Kahnweiler's stockbook in spring 1913: no. 1254 (plate 7), no. 1255 (plate 14), no. 1256 (plate 15). With thanks to Pepe Karmel for sharing his transcription of Kahnweiler's photograph files and stockbook. Plates 73 and 74, from spring 1913, are also pasted on paperboard supports.

29. Laurens 1967, n.p. Quoted in Rowell 1979, p. 14.

30. The copy of *L'Illustration théatrale* tucked above and behind *Guitar* at right also remains constant, although it, unlike *Guitar*, is in each case partially covered. See Baldassari 2000, pp. 78–83, for extended discussion of the significance of *L'Illustration théatrale*. It should be noted that while Picasso could regularly view his completed works in photographs provided by Kahnweiler (see note 45, below), photographing every individual work on paper would not have been cost-effective for either Picasso or his dealer to undertake, and so arrangements of this type involving multiple works on paper may have had some practical inspiration as well.

31. See Rosenblum 1973 and Leighten 1989, pp. 121–42, regarding the contents of the newspaper cutouts.

32. Raynal, "L'Exposition de la 'Section d'Or,'" *La Section d'Or* 1, no. 1 (October 9, 1912): 2–5. In Antliff and Leighten 2008, p. 335, doc. 47. See Krauss 1998, pp. 25–28, on the shifting density, opacity, and meaning of newspaper fragments in Picasso's collages.

33. Poggi, in conversation with the author, June 9, 2009. We discussed how Picasso makes literal the distortions of perspectival illusionism. See also Poggi 2010 and Zelevansky 1992, pp. 130, 142.

34. See Chronology, p. 98, regarding the evidence that helps us to place this composition between late January and early March 1913.

35. The discussion that follows is indebted to a conversation with Elizabeth Cowling, Blair Hartzell, and Scott Gerson regarding plates 48–52 and *Head of a Man* (plate 53), which Poggi argues is the surviving portion of the 1913 construction visible in these staged studio photographs. See Poggi 1988, pp. 320, 322 n 35. Our examination of plates 48–52 as well as fig. 6—specifically the manner in which the edges of the large-scale support read as canvas in these images—convinced us that *Construction with Guitar Player* was not cut down, reworked, and transformed into *Head of a Man*, a work on paper. The canvas support of *Construction with Guitar Player* may have been destroyed or simply cut down, as the removal of the pasted-on newspaper arms left some light damage (see fig. 6), or it may have been transformed into a very different finished canvas of comparable dimensions, such as *Man Leaning on a Table*, Paris, 1915–16 (Pinacoteca Giovanni e Marella Agnelli, Turin; DR 889).

36. See Baldassari 1997, pp. 116–17, for an eloquent and succinct discussion of these issues. Juan José Lahuerta also provided thoughtful assessments of these photographs. The author in conversation with Lahuerta, June 1, 2009, and Lahuerta 1996. Edward Fry described this work as functioning "*neither* as a work of art *nor* as a photograph of a work of art, but as a manifesto/demonstration, as is so often the case with Picasso's photography." Fry 1988, p. 306 n 31.

37. Baldassari 1994, p. 229.

38. See Tabart 2000 for a detailed study of the relationship between Constantin Brancusi and Marcel Duchamp. The readymades Duchamp arranged in his studio, analogous in some ways with his friend Brancusi's combinatorial practice utilizing high-contrast bases, parallel Picasso's selectively shifting, contingent presentation of both found and handmade objects in his studio. With thanks to Jeffrey Weiss for noting this, in conversation with the author, May 12, 2010.

39. Pages 67R, 67V, and 75R (plate 68) in the sketchbook Picasso kept in spring 1913 indicate, in the artist's handwritten inscriptions, the palette of colors he worked with in Céret and specifically the colored papers he incorporated into papiers collés and ephemeral wall reliefs.

40. Caizergues and Seckel 1992, p. 102. For discussion of the earliest published mention of cardboard reliefs and works incorporating wallpaper and newspaper—both authored by Guillaume Apollinaire—see Chronology, p. 98. Read's commentary in Apollinaire 2004 and Read 2008 provide insightful analyses of Apollinaire's work and his relationship with Picasso.

41. See Rosenblum 1971, most specifically regarding the 1883 newspaper; Cowling 1995 on Picasso's cutting, pasting, and pinning; and Karmel 1997 on Picasso's output in Céret.

42. Notable related works, all executed in Céret in spring 1913, include *Head* (Musée national Picasso, Paris; DR 594), *Guitar* (formerly collection André Breton, Paris, and present whereabouts unknown; DR 596), and *Guitar* (Musée national Picasso, Paris; DR 597). To these one might add the small paper *Guitar* Picasso sent to Apollinaire on May 29, 1913, now in the Archives Picasso, Musée national Picasso, Paris. For an image of this work and a transcription of the letter it accompanied, see Caizergues and Seckel 1992, p. 106, fig. 30.

43. For a detailed discussion of plate 74, see Cox 2009, pp. 16–20. Rubin 1972, p. 79, notes the punning of ears and stringed instruments in Picasso's head compositions.

44. A significant number of works on paper dated to spring 1913 and made in Céret, now in the collection of the Musée national Picasso, relate closely to *Guitar and Bottle of Bass* (plate 81). Those incorporating the distinctive wallpaper seen in plate 83 include *Guitar on a Table* (Private collection; DR 599) and *Bottle of Vieux Marc, Glass, and Newspaper* (Centre Pompidou, Musée national d'art moderne, Paris; DR 600).

45. "*J'ai reçu ier les photos que sont bien et que me plaisent toutjours, car j'ai la surprise. Je vois mes tableaux autrement que côme ils sont.*" Monod-Fontaine 1984, p. 170. Kahnweiler systematically photographed paintings and some papiers collés as they entered his gallery's inventory, and these photographs were eagerly awaited by his artists. Before departing for Céret, Picasso made available to Kahnweiler a group of mainly 1912–13 works, and it is presumably these newly photographed works to which Picasso refers. There is no indication that the *Soirées de Paris* photographs numbered among this group. See Baldassari 1994 for further discussion of Picasso's keen interest in photography in this period.

46. Richardson 1996, p. 285. As of September 20, 1913, Picasso and Gouel were still receiving visitors at boulevard Raspail, such as Apollinaire, who was invited for a lunch of roast rabbit that day. Picasso, letter to Apollinaire, September 20, 1913. Caizergues and Seckel 1992, pp. 108–9, fig. 31.

47. Vanessa Bell to Duncan Grant, January 14, [1914], in Bell 1993, pp. 153–55, discusses the forthcoming trip, as does Roger Fry, letter to Charles Vildrac, January 1, 1914, and letter to R. C. Trevelyan, January 16, 1914, in Fry 1972, vol. 2, pp. 376–77. Cumulatively, the contents of these letters indicate that the group could not have visited Picasso's studio before January 17, 1914. We are very grateful for the assistance of Allison Foster, Archive Cataloguer, Tate Gallery Archives, London, in bringing to our attention an unpublished letter by Vanessa Bell of January 22, 1914, addressed from London to Clive Bell, describing her trip home from Paris.

48. Bell to Grant, Wednesday [1914], Bell 1993, p. 160. The letter bears no specific date or postmark, only "Wednesday," which must fall after January 22 and before the month of April, based on its contents. Fry notes simply in an undated letter to Grant that covers many of the same events as Bell's letter, "We saw Picasso's studio in Paris, but I expect Vanessa'll have told you about that." Fry 1972, vol. 2, p. 378.

49. Richardson 1996, p. 256. John Richardson proposes that Bell's letter can be used to provide a *terminus post quem* for Picasso's sheet metal *Guitar*, pushing its date to sometime after Bell's studio visit. For years it was believed that Picasso made the sheet metal *Guitar* in 1912, based largely on information the artist provided in retrospective accounts. Christian Zervos, Roland Penrose, and William Rubin, all of whom spent time with the artist, dated the work to 1912. We are grateful to Diana Widmaier Picasso, who is currently preparing a catalogue raisonné of Picasso's sculptures, for informing us that the photograph of the sheet metal *Guitar* published as Zervos II(2) 773 in 1942 bears the inscription "1912" on the verso, in what appears to be the artist's hand. This almost certainly refers to the cardboard *Guitar*; the date of the original idea was most vivid and significant for the artist.

50. Salmon 1919, note to the foreword. His original manuscript has not been located; perhaps it may offer more definitive insight into whether the sheet metal *Guitar* was executed before or after World War I.

51. Salmon 1919, pp. 103–4. For the author's recollections of *Guitar* in his memoirs, see Salmon 1945, pp. 81–82, and Salmon 1956, p. 240.

52. The first published image, Zervos II(2) 773, appeared in 1942. To date, no studio photographs have been located that show the sheet metal *Guitar* on view in the studio at rue Schoelcher.

53. See, for example, Eluard 1944, p. 86, describing the cardboard *Guitar* as "*tôle*" (sheet metal).

54. Richardson 1996, p. 104. We wish to express our sincere gratitude to Bernard Ruiz-Picasso and Cécile de Godefroy, Researcher, Fundación Almine y Bernard Ruiz-Picasso para el Arte, Madrid, for making this photograph available for publication.

55. The rare exception to this rule: Picasso gave his spring 1914 wood-and-upholstery construction, *Still Life* (Tate, London; DR 746), to poet Paul Eluard in the late 1930s. Early examples of published reproductions of Picasso's Cubist reliefs, after *Les Soirées de Paris*, include Raynal 1921, Cocteau 1923, and Eluard 1944; early published discussions focused on his sculptural output include Breton 1972 (first published 1933), González 1936 (based on a longer 1932 manuscript),

and Kahnweiler 1949. The artist strongly rebuffed Penrose's requests to include sculpture in his exhibition *Picasso*, presented at Tate Gallery, London, July 6–September 18, 1960, and Penrose resolved to drop the matter so as not to jeopardize the entire show. See Penrose, letter to Gabriel White, February 10, 1960, Arts Council of Great Britain Archives, Victoria and Albert Museum, London. Quoted in part in Cowling 2006, p. 225.

56. Cowling 2006, p. 256. The earliest letter in The Museum of Modern Art Archives (hereafter MoMA Archives) between Penrose and Barr regarding firm plans for a sculpture retrospective dates to January 8, 1965, and contains references to earlier conversations. MoMA Archives, Alfred H. Barr Papers (hereafter AHB Papers), I.517.

57. Dealer Louise Leiris, along with the artist's wife, Jacqueline, had advised Penrose that this would all work out to the advantage of the sculpture show, saying, "For heaven's sake wait until everything is out of the house—at that moment it should be easy." Penrose, letter to Monroe Wheeler, September 28, 1966. MoMA Archives, AHB Papers, 12.II.L. This was indeed the case, though Picasso took his time to consent to each venue, and Barr was only able to secure the show for the Museum in person, on January 9, 1967. See Arts Council Great Britain Archive, Victoria and Albert Museum, London. Hayward Gallery Material: Exhibition Files, 1945–1995, ACGB/121/847, 857, and MoMA Archives, AHB Papers, 12.II.L.

58. *Hommage à Pablo Picasso* was presented at the Grand Palais and Petit Palais, Paris, November 19, 1966–February 12, 1967; *Picasso: Sculpture, Ceramics, Graphic Work* at Tate Gallery, London, June 9–August 13, 1967; and *The Sculpture of Picasso* at The Museum of Modern Art, New York, October 11, 1967–January 1, 1968 (MoMA Exh. #841).

59. See Barr's travel notebook labeled "1966–67 SPAIN/PARIS/(Picasso)," p. 13. MoMA Archives, AHB Papers, 9.E.I.

60. Barr, letter to Kahnweiler, February 6, 1967. MoMA Archives, AHB Papers, 12.III.A.5. We might reasonably infer that this letter was written with the understanding that any sculptures purchased would ultimately enter the Museum's collection as part of the Nelson A. Rockefeller Bequest. For documentation of Barr's efforts as art advisor to Nelson A. Rockefeller, see MoMA Archives, AHB Papers, Series 18.

61. Kahnweiler to Barr, February 9, 1967. MoMA Archives, AHB Papers, 12.III.A.5. There is a second copy of Kahnweiler's reply in MoMA Archives, AHB/NAR Correspondence, 18.I.A.9.

62. At first Picasso said he would think it over, as Kahnweiler relayed to Barr in a letter of November 21, 1967. MoMA Archives, AHB Papers, 12.II.L. The artist's health subsequently declined, and by the following month he was "unwilling to discuss the matter." See Kahnweiler, letter to d'Harnoncourt, December 19, 1967. MoMA Archives, AHB Papers, 12.II.L.

63. James Thrall Soby, letter to Barr, July 15, 1969. MoMA Archives, AHB Papers, I.540. From 1940 to 1967 Soby served the Museum in countless capacities, chief among them as director of over a dozen major exhibitions and advisor to the Committee on the Museum Collections.

64. Rubin 1996, p. 24.

65. Rubin's account of the acquisition of the sheet metal *Guitar* has appeared in multiple published sources, chief among them Rubin 1972, Rubin 1974, Rubin 1980, Rubin 1984, Rubin 1989, Rubin 1996, Rubin 1997, and Rubin 2006. To these will be added the forthcoming book, prepared by Phyllis Hattis, on Rubin's many acquisitions for the Museum (anticipated publication date spring 2011). The confidential minutes of the meeting of the Committee on Painting and Sculpture, held on March 9, 1971, notably record that Rubin showed Picasso photo albums of the Museum's holdings of the artist's work so that he could see its strengths as well as what it lacked. MoMA, Department of Painting and Sculpture, Acquisition Committee Minutes.

66. The possibility of an exchange, first suggested by dealer Ernst Beyeler, apparently appealed to the artist a great deal. See Beyeler, letter to Rubin, January 19, 1971, recounting Jean Planque's conversation with Picasso about Paul Cézanne's painting *The Rooftops of L'Estaque* (1883–85). The artist ultimately declined to make the trade, possibly because the painting had been relined, and he indeed already owned several excellent Cézannes, including a superior canvas of the same subject (see Rubin 2006, p. 258); it was his wife Jacqueline's wish that the story of the offer of an exchange be kept out of the newspapers.

Much to Rubin's chagrin, Douglas Cooper published an article detailing the proposed trade, and while Rubin wrote to the editor with corrections to the story, it was decided that the entire episode should go without the Museum's comment in deference to Jacqueline. See MoMA, Department of Painting and Sculpture, Museum Collection Files, Picasso 94.1971, and Cooper 1971. *The Rooftops of L'Estaque* was used instead as part of an exchange with Walter P. Chrysler for Picasso's *The Charnel House*, Paris, 1944–45 (MoMA, New York; Z XIV 76); coincidentally, this exchange was proposed at the same March 9, 1971, acquisition meeting as the sheet metal *Guitar*. MoMA, Department of Painting and Sculpture, Acquisition Committee Minutes.

67. MoMA Archives holds roughly one hundred clippings from February to June 1971 on the acquisition of the sheet metal *Guitar*. Department of Public Information Records, II.A.488 and II.A.489.

68. Rubin, letter to Picasso, February 10, 1971, postscript. MoMA, Department of Painting and Sculpture, Museum Collection Files, Picasso 94.1971.

69. Kramer 1971. Kramer's comments are drawn almost verbatim from Rubin, "Important Newly Acquired Painting and Sculpture at The Museum of Modern Art," The Museum of Modern Art Library, press releases nos. 33 and 33A.

70. Ibid.

71. Poggi first contacted the Museum in December 2005, asking about the complementary elements documented in the *Soirées de Paris* photograph. Senior Paper Conservator Karl Buchberg recalled that a cardboard piece matching the tabletop's description had indeed been preserved in Paper Conservation storage.

72. The box purportedly bears a label addressed to 5 *bis*, rue Schoelcher identifying the original contents as "*DEUX PANTALONS ROUGES*." See Rubin in Zelevansky 1992, pp. 241, 260 n 9. See Chronology, p. 99, regarding Picasso's move from Montparnasse to the suburb of Montrouge in October 1916.

73. Picasso knew he had saved only the instrument and the tabletop and conveyed this to Rubin in conversation in 1971. See Rubin 1972, p. 207.

74. Rubin, letter to Judith Cousins, August 31, 1973: "I will be returning on Sunday September 9th, carrying the cardboard maquette for the Picasso Guitar with me. I will have my own affidavit regarding its origin, date, and originality with me, and I anticipate no difficulties with the American custom authorities." MoMA, Department of Painting and Sculpture, Museum Collection Files, Picasso 640.1973.

75. The earliest documented examination of *Guitar* records six pieces, designated a–f, and their individual dimensions. The tabletop can be identified as item "b) 20 ⅞ h. × 10" w. (53.0 × 25.5 cm) (irreg.)," and under the condition information the presence of "tack holes" is noted. See Maquette for GUITAR, Painting & Sculpture Collection Worksheet, April 1978 (date of object examination). MoMA, Department of Painting and Sculpture, Museum Collection Files, Picasso 640.1973.

76. The Museum's Study Collection seems, historically, to have been used as a repository for works of uncertain or secondary status by major artists.

77. A handwritten note, dated June 1, 1979, records Edward F. Fry's May 31, 1979, visit to the Museum to study the cardboard *Guitar* and his assertion that "the cardboard Maquette for Guitar precedes the metal version of Guitar." MoMA, Department of Painting and Sculpture, Museum Collection Files, Picasso 640.1973. This disassembled state and the reassembly process seem to have gone undocumented by Museum staff. Fry presented his images as slides accompanying his lecture "Picasso's 1912 *Guitar*," 69th Annual College Art Association Conference, 1981. See University of Pennsylvania Archives, Edward F. Fry Papers, Ms. Coll 651, Folder 911.

78. Fry asserted that "careful measurement [his own] has shown that the disassembled cardboard *Guitar* served as a template for the sheet metal version." University of Pennsylvania Archives, Edward F. Fry Papers, Ms. Coll 651, Folder 909, p. 13. The comparison of measurements carried out by Scott Gerson on August 24, 2010, confirms that many of the dimensions of the two works' component parts are, in fact, remarkably close to one another. There is no direct physical evidence suggesting that any cardboard *Guitar* parts served as templates. However, the close dimensional relationships suggest that the cardboard version served as much more than just the inspiration for its metal counterpart. It is possible, even likely, that templates were made from (or perhaps as the basis of) the cardboard *Guitar* and that these templates were (re)used to make the sheet metal *Guitar*.

79. As noted on p. 99, the cardboard *Guitar* was never publicly exhibited by Picasso in his lifetime. However, the cardboard *Violin* (plate 84), the element saved from the artist's larger relief construction (plate 83), was included in the Paris retrospective *Hommage à Pablo Picasso* in 1966–67, and in subsequent sculpture exhibitions in London and New York, indicating that Picasso was willing to exhibit selectively saved elements. While works were being assembled and inventoried for the Paris exhibition, Penrose observed Picasso's enthusiasm as he fished out from the depths of his studio his Cubist reliefs, "which he had formerly discarded as hopelessly damaged and is now putting together again." Penrose to Monroe Wheeler, September 28, 1966. MoMA Archives, AHB Papers, 12.II.L.

80. See Chronology, p. 98, on Apollinaire's statements on collage and construction.

81. Breton 1972, p. 109.

82. Décaudin 1965, p. 240. Quoted in Read 2008, p. 98.

83. See Cousins 1989, pp. 430–33, and Rubin 1989, pp. 51–53, on the movements of Picasso and his friends from July 1914 on.

84. "A Conversation with Richard Serra" (September 21 and 28, 2006), in McShine and Cooke 2007, p. 19.

85. Poggi has presented a notable exception to the existing standard of materially neutral accounts. Bois 1990 remains an absolutely key text on the sheet metal *Guitar*.

86. Richard Serra in McShine and Cooke 2007, p. 18.

87. Michael Baxandall provides the essential model for this approach: "If we think of Y rather than X as the agent, the vocabulary is much richer and more attractively diversified: draw on, resort to, avail oneself of, appropriate from." Baxandall 1985, p. 59.

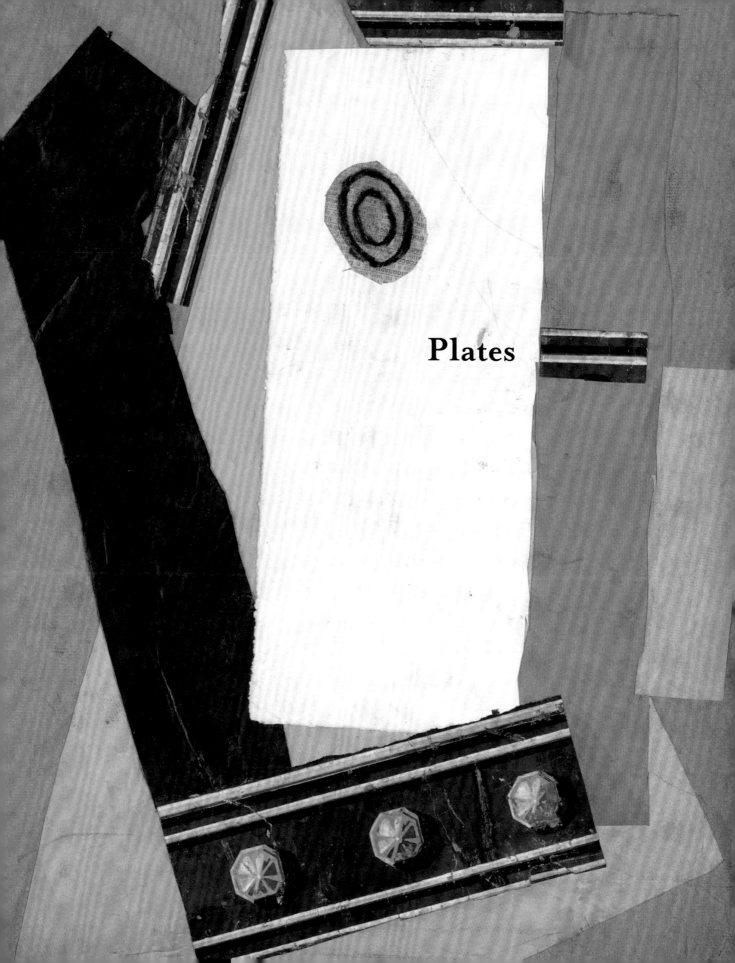

Plates

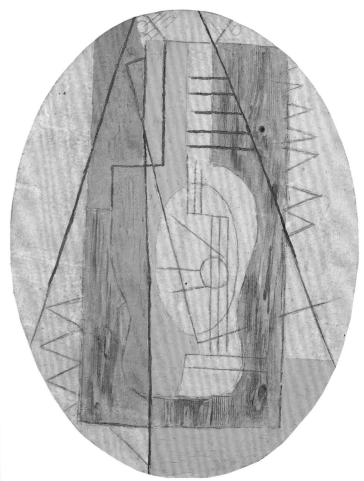

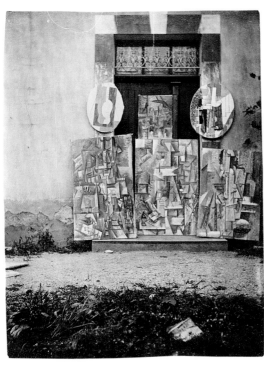

1.

Installation in front of
Villa des Clochettes.
August or September
1912. Gelatin silver print,
4 ¼ × 3 ⅜″ (10.8 × 8.5 cm)

2.

Guitar. Summer 1912.
Oil and charcoal on
canvas, 25 ⅜ × 19 ¹¹⁄₁₆″
(64.5 × 50 cm)

3.

Guitar. Begun summer
1912, completed winter
1912–13. Oil and charcoal
on canvas, 28 ½ × 23 ⅝″
(72.5 × 60 cm)

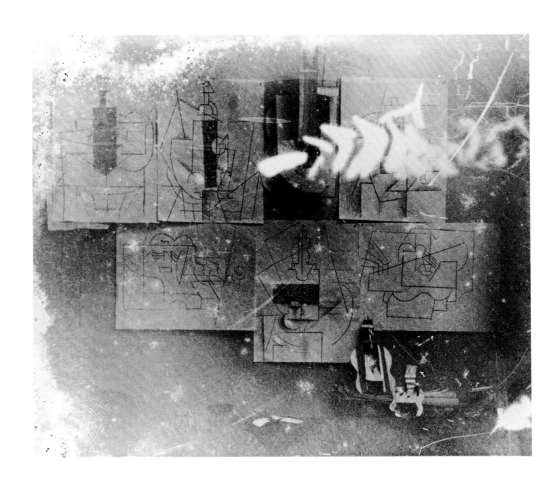

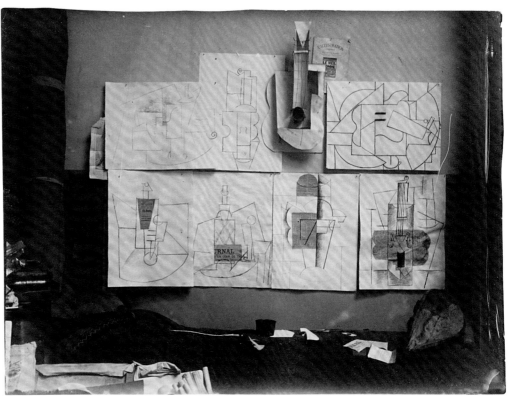

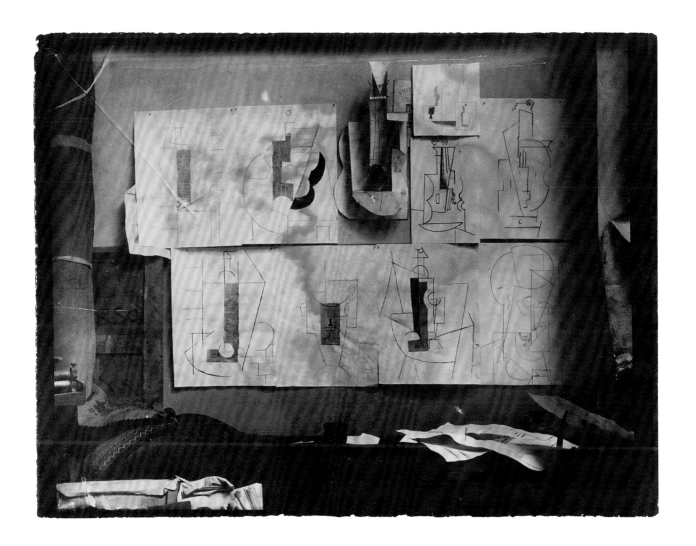

4.
Installation in the
artist's studio at 242,
boulevard Raspail.
December 4, 1912, or
later. Modern print
from original glass
negative, 3 9/16 × 4 3/4"
(9 × 12 cm)

5.
Installation in the
artist's studio at 242,
boulevard Raspail.
December 9, 1912,
or later. Gelatin silver
print, 3 3/8 × 4 1/2"
(8.6 × 11.5 cm)

6.
Installation in the
artist's studio at 242,
boulevard Raspail.
December 9 or 14, 1912,
or later. Gelatin silver
print, 3 3/8 × 4 11/16"
(8.6 × 11.9 cm)

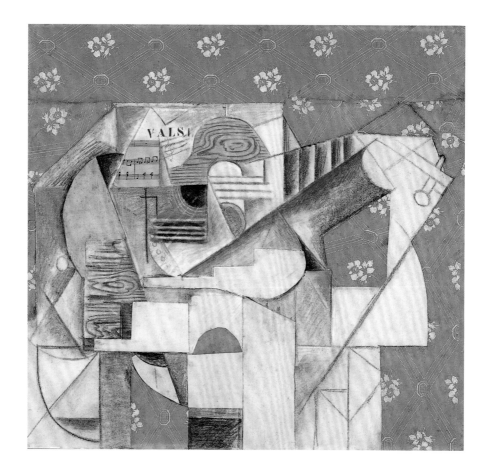

7.

Guitar and Sheet Music.
Autumn 1912. Cut-and-
pasted wallpaper and
sheet music, pastel, and
charcoal on paperboard,
22 ¹³⁄₁₆ × 24″ (58 × 61 cm)

8.

Bottle, Guitar, and Pipe.
Autumn 1912. Oil, enamel,
sand, and charcoal on
canvas, 23 ⅝ × 28 ¾″
(60 × 73 cm)

9.

Guitar on a Table.
Autumn 1912. Oil, sand,
and charcoal on
canvas, 20 ⅛ × 24 ¼″
(51.1 × 61.6 cm)

10.

Guitar on a Table.
December 1912 or later.
Cut-and-pasted
wallpaper and charcoal
on paper, 18 ¾ × 24 ⅝″
(47.5 × 62.5 cm)

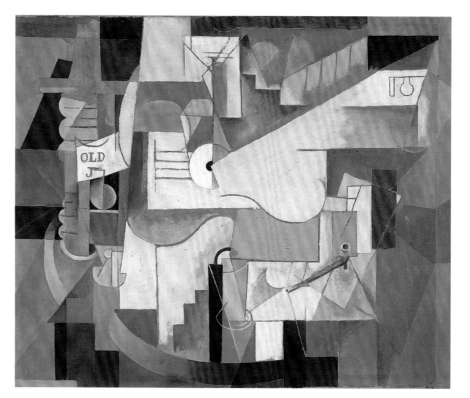

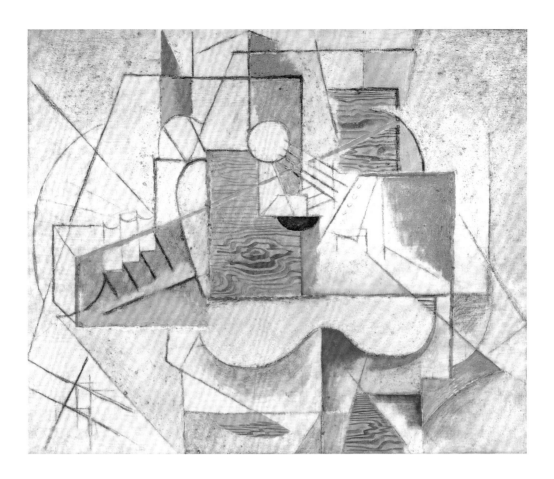

11.

Guitar. October–December 1912. Paperboard, paper, string, and painted wire, 25 ¾ × 13 × 7 ½" (65.1 × 33 × 19 cm)

12.

Guitar. December 3, 1912, or later. Paperboard, cut-and-pasted newspaper, colored paper, and canvas, string, ink, and pencil, 13 × 7 1/16 × 3 ¾" (33 × 18 × 9.5 cm)

13.

Guitar. December 3, 1912, or later. Paperboard, cut-and-pasted newspaper, and canvas, string, and pencil, 8 11/16 × 5 11/16 × 2 ¾" (22 × 14.5 × 7 cm)

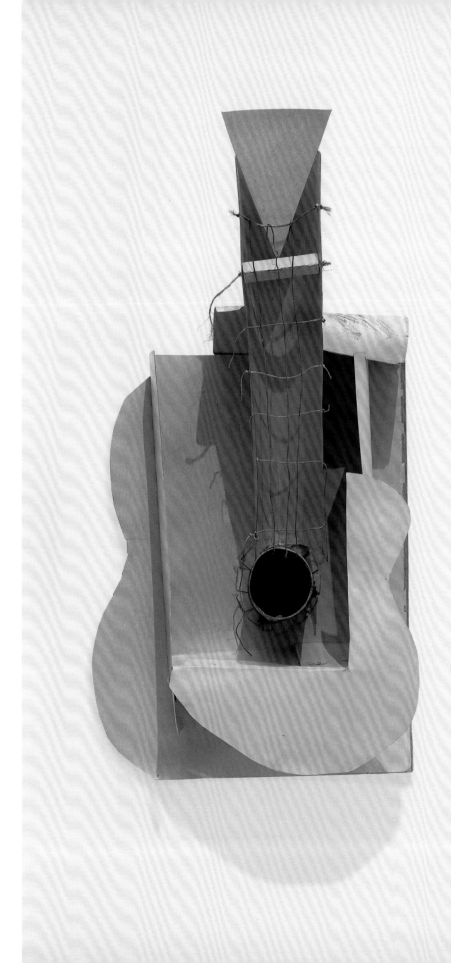

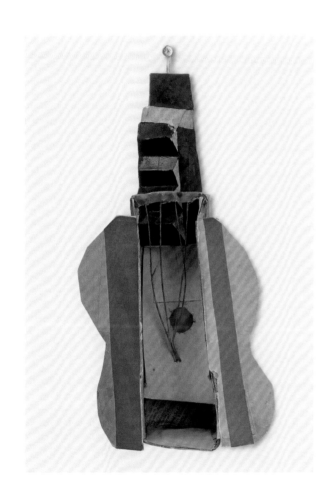

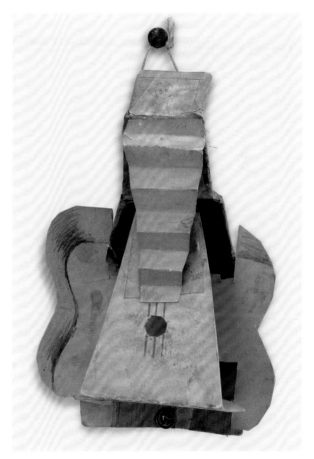

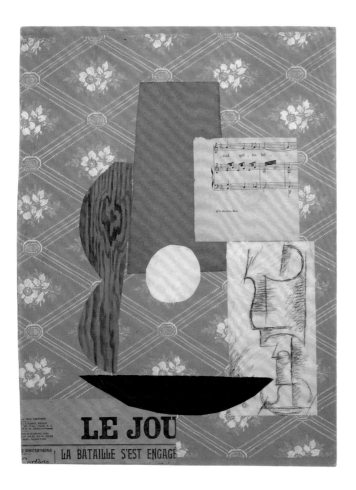

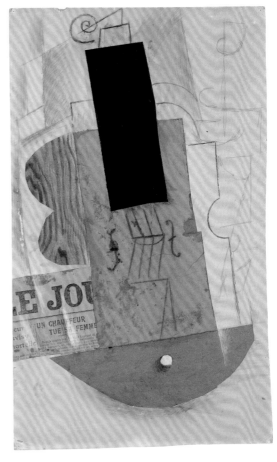

14.

Guitar, Sheet Music, and Glass. November 18, 1912, or later. Cut-and-pasted wallpaper, newspaper, sheet music, colored paper, paper, and hand-painted faux bois paper, charcoal, and gouache on paperboard, 18 ⅞ × 14 ⅜" (47.9 × 36.5 cm)

15.

Newspaper and Violin. December 1, 1912, or later. Cut-and-pasted newspaper, colored paper, paper, and hand-painted faux bois paper, charcoal, ink, pencil, and chalk on paperboard, 18 ¹¹⁄₁₆ × 11 ³⁄₁₆" (47.5 × 28.4 cm)

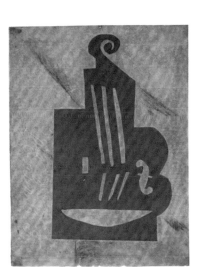

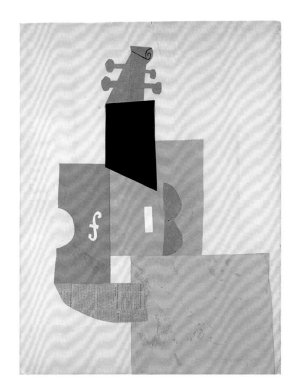

16.

Violin. Autumn–winter 1912. Cut-and-pasted paper inside folded-and-pasted paper with charcoal, 12 ⅜ × 9 ¼" (31.5 × 23.5 cm)

17.

Violin and Sheet Music. Autumn 1912. Cut-and-pasted wallpaper, sheet music, and colored paper on cardboard box lid, 30 ¹¹⁄₁₆ × 24 ¹³⁄₁₆" (78 × 63 cm)

18.

Violin. November 18, 1912, or later. Cut-and-pasted wallpaper, newspaper, colored paper, and paper, ink, charcoal, and pencil on paperboard, 25 ⁹⁄₁₆ × 19 ¹¹⁄₁₆" (65 × 50 cm)

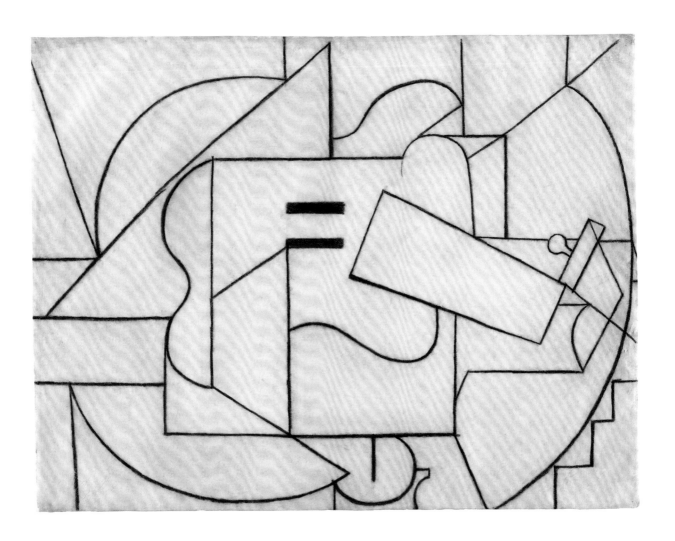

19.

Guitar. December 1912
or later. Charcoal
on paper, 18 ½ × 24 ⅜″
(47 × 61.9 cm)

20.

*Musical Score and
Guitar.* Autumn 1912.
Cut, pasted, and pinned
colored paper, sheet
music, and paper, and
charcoal on colored
paper, 16 ¾ × 18 ⅞″
(42.5 × 48 cm)

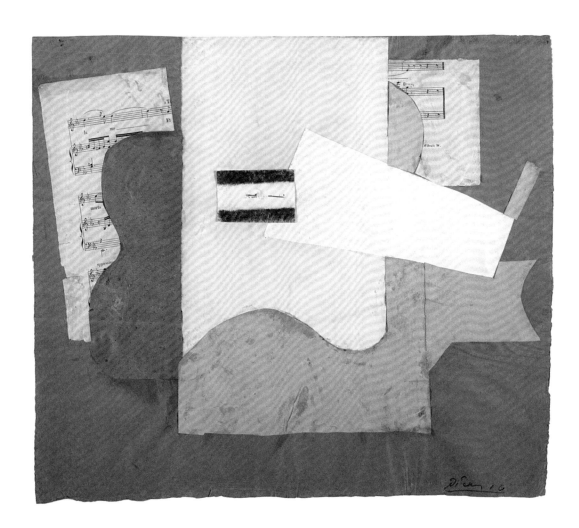

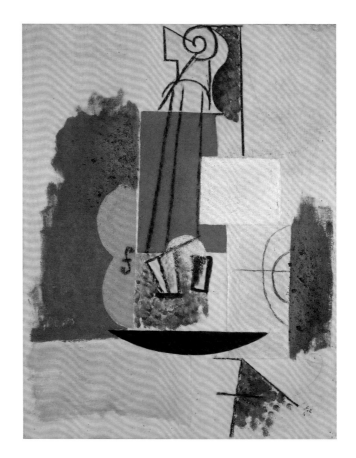

21.

Violin. Autumn 1912.
Oil, sand, and charcoal
on canvas, 21 ⅝ × 16 ⁵⁄₁₆″
(55 × 43 cm)

22.

Violin. December 1912
or later. Charcoal
on paper, 18 ½ × 24 ½″
(47 × 62.2 cm)

23.

Musical Instruments.
Begun summer 1912,
completed early 1913.
Enamel, oil, gesso,
sawdust, and charcoal
on canvas, 38 ⅝ × 31 ½″
(98 × 80 cm)

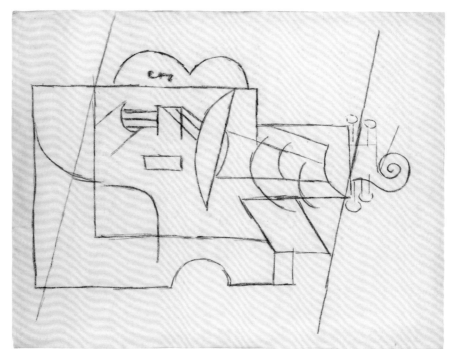

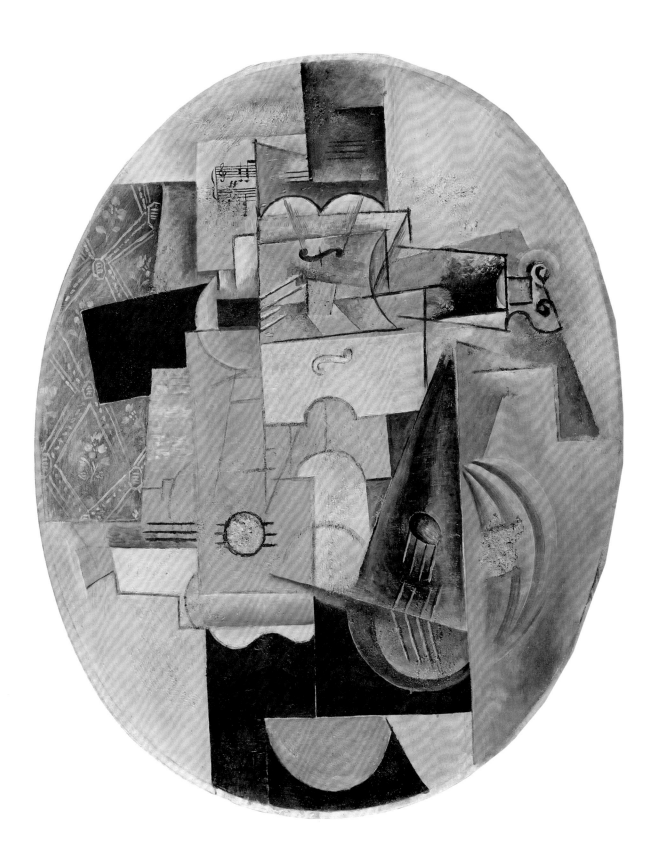

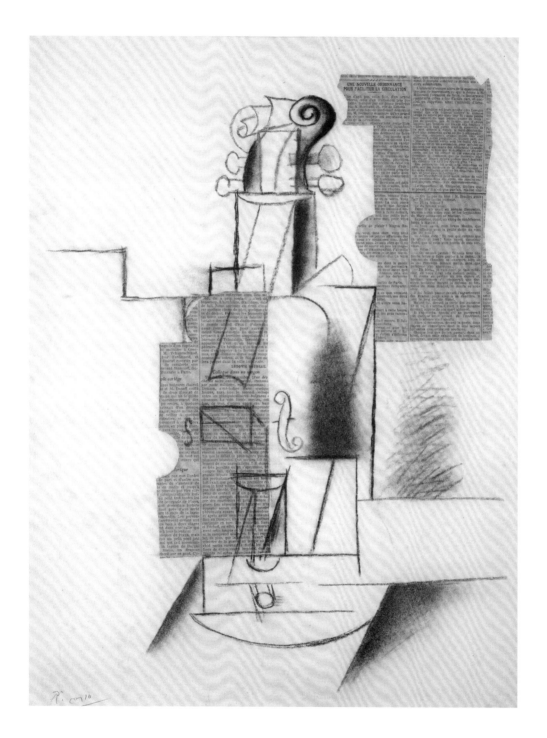

24.

Violin. December 3, 1912, or later. Cut-and-pasted newspaper and charcoal on paper, 24 ⁷⁄₁₆ × 18 ½″ (62 × 47 cm)

25.

Violin. December 1912 or later. Charcoal on paper, 18 ⅛ × 12 ¹³⁄₁₆″ (46 × 32.5 cm)

26.

Siphon, Glass, Newspaper, and Violin. December 3, 1912, or later. Cut-and-pasted newspaper, hand-painted faux bois paper, and paper, and charcoal on paper, 18 ½ × 24 ⅝″ (47 × 62.5 cm)

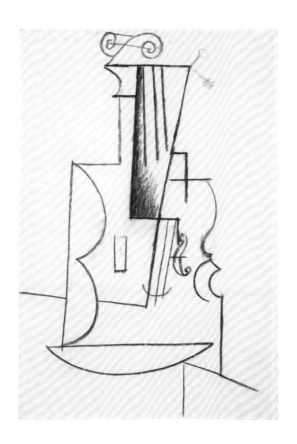

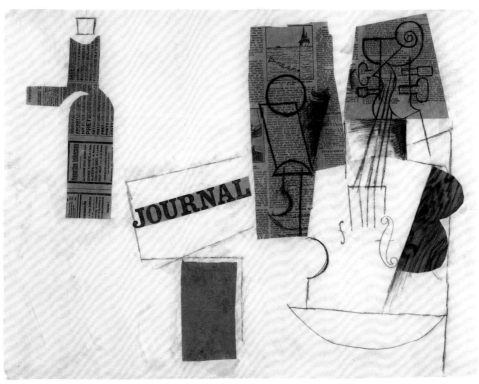

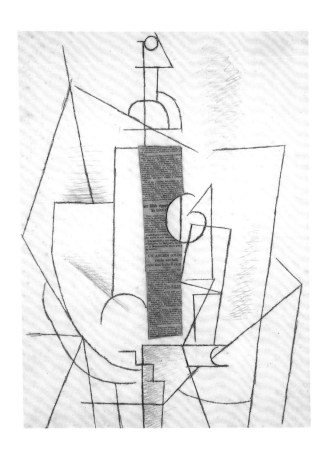

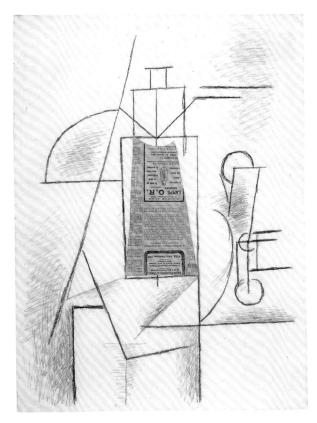

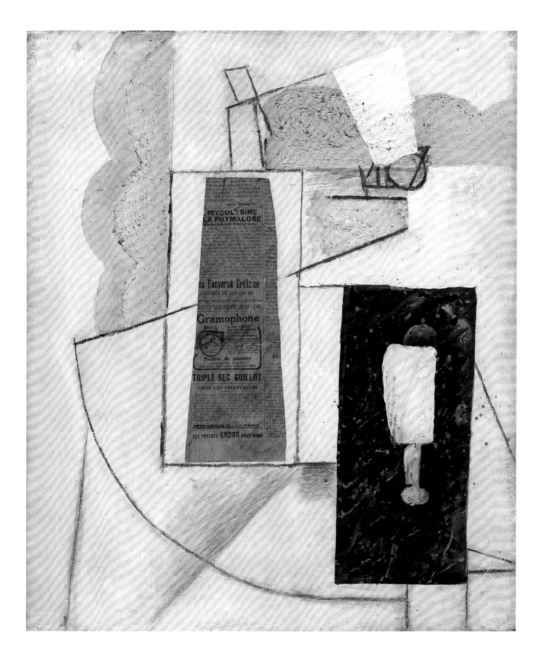

27.

Bottle and Wineglass. December 4, 1912, or later. Cut-and-pasted newspaper, charcoal, and pencil on paper, 23 3/16 × 18 1/16" (58.9 × 45.8 cm)

28.

Bottle and Wineglass. December 3, 1912, or later. Cut-and-pasted newspaper, charcoal, and pencil on paper, 24 7/16 × 18 9/16" (62 × 47.1 cm)

29.

Bottle and Wineglass. December 3, 1912, or later. Oil, sand, cut-and-pasted newspaper, charcoal, and pencil on canvas, 21 3/4 × 18 1/4" (55.2 × 46.4 cm)

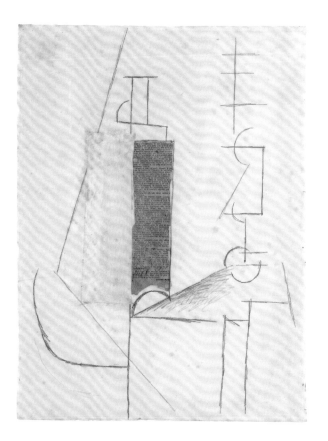

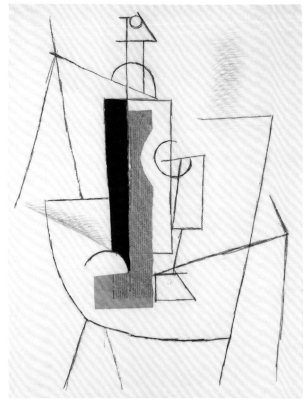

30.

Bottle and Wineglass.
December 4, 1912, or
later. Cut-and-pasted
newspaper, charcoal,
pencil, and cut-and-
pasted paper over ink
on paper, 24 ½ × 18 ¹¹⁄₁₆″
(62.2 × 47.5 cm)

31.

*Bottle and Wineglass
on a Table.* December 3,
1912, or later. Cut-and-
pasted newspaper, ink,
charcoal, and pencil
on paper, 24 ⅝ × 18 ¾″
(62.6 × 47.6 cm)

32.

Bottle on a Table.
December 8, 1912, or
later. Cut-and-pasted
newspaper and charcoal
on paper, 24 ⁷⁄₁₆ × 18 ¹¹⁄₁₆″
(62 × 47.5 cm)

33.

*Bottle of Marc de
Bourgogne, Wineglass,
and Newspaper.*
December 9, 1912, or
later. Oil, sand, cut-and-
pasted newspaper,
and charcoal on
canvas, 18 ¼ × 15 ⅛″
(46.3 × 38.4 cm)

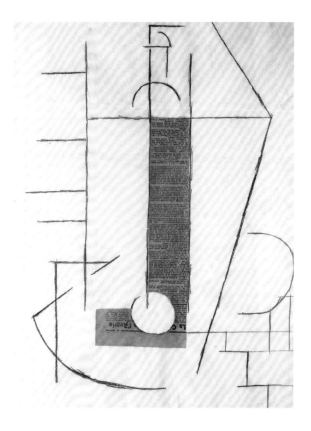 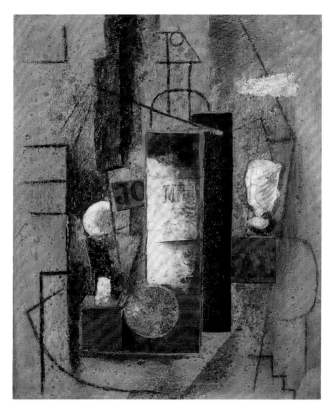

34.

Bottle, Cup, and Newspaper. December 4, 1912, or later. Cut-and-pasted newspaper, charcoal, and pencil on paper, 24 ¹³⁄₁₆ × 19 ⁵⁄₁₆″ (63 × 49 cm)

35.

Bottle, Wineglass, and Newspaper on a Table. December 4, 1912, or later. Cut-and-pasted newspaper, charcoal, and gouache on paper, 24 ⁷⁄₁₆ × 18 ⅞″ (62 × 48 cm)

36.

Bottle and Violin on a Table. December 3, 1912, or later. Cut-and-pasted newspaper and charcoal on paper, 24 × 18 ⁵⁄₁₆″ (61 × 46.5 cm)

37.

Composition with a Violin. December 8, 1912, or later. Cut-and-pasted newspaper, pencil, charcoal, and ink on paper, 24 × 18 ⅜″ (61 × 46.7 cm)

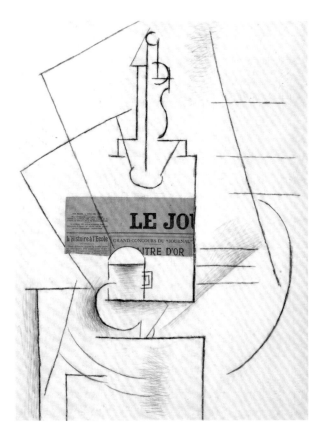

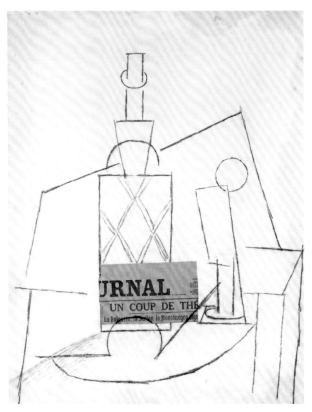

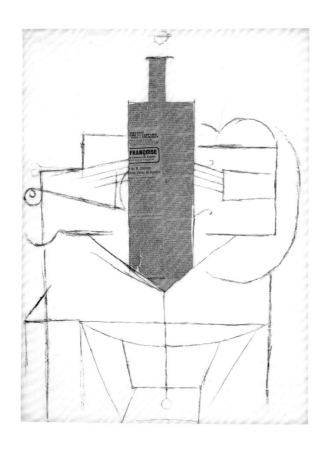

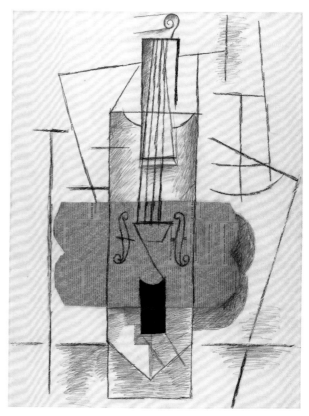

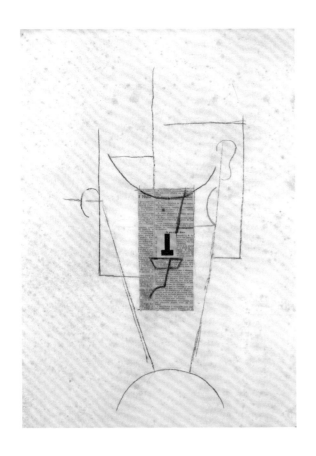

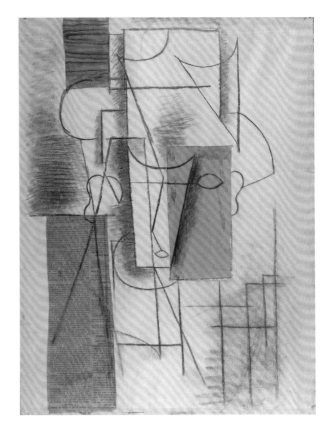

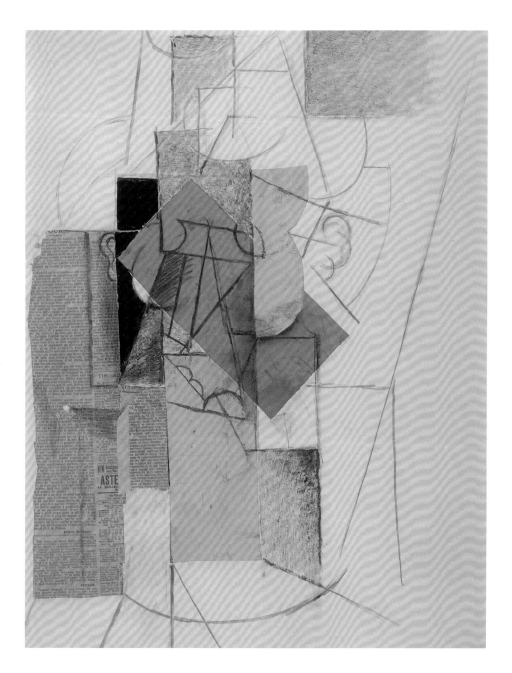

38.

Head of a Man.
December 9, 1912, or
later. Cut-and-pasted
newspaper and charcoal
on paper, 24 7/16 × 18 ½"
(62 × 47 cm)

39.

Head of a Man.
December 2, 1912, or
later. Cut-and-pasted
newspaper, colored
paper, and hand-painted
faux bois paper, and
charcoal on paper,
24 5/8 × 18 ½"
(62.5 × 47 cm)

40.

*Head of a Man with
a Hat.* December 2, 1912,
or later. Cut-and-pasted
newspaper and colored
paper, oil, ink, sand,
and charcoal on paper,
25 9/16 × 19 11/16"
(65 × 50 cm)

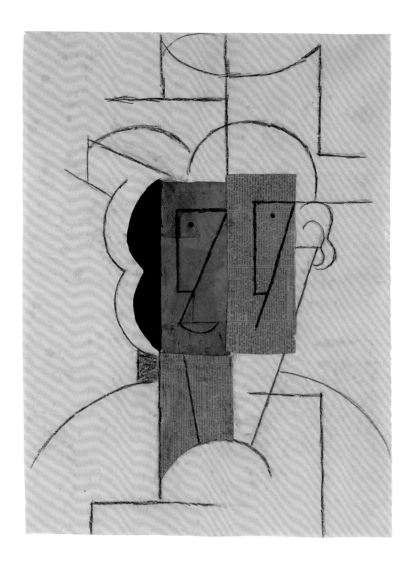

41.

*Head of a Man with a
Hat.* December 3, 1912,
or later. Cut-and-pasted
newspaper and colored
paper, ink, charcoal,
and crayon on paper,
24 ½ × 18 ⅝"
(62.2 × 47.3 cm)

42.

*Man with a Hat and a
Violin.* December 9, 1912,
or later. Cut-and-pasted
newspaper and charcoal
on two joined sheets
of paper, 49 × 18 ⅞"
(124.5 × 47.9 cm)

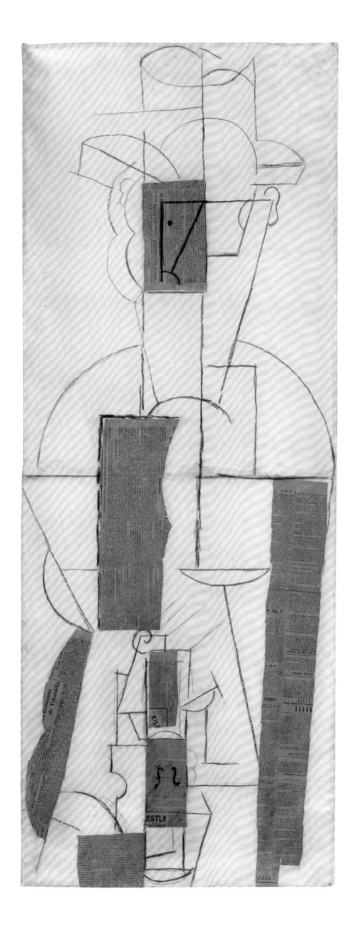

43.

Guitar, Gas Jet, and Bottle.
Early 1913. Oil, charcoal,
tinted varnish, and grit
on canvas, 27 ¹¹⁄₁₆ × 21 ¾"
(70.4 × 55.3 cm)

44.

Glass, Guitar, and Bottle.
Early 1913. Oil, cut-and-
pasted newspaper, gesso,
charcoal, and pencil
on canvas, 25 ¾ × 21 ⅛"
(65.4 × 53.6 cm)

45.

Guitar and Bottle.
December 1912 or later.
Pencil on paper,
12 ⅝ × 12 ⅜"
(32 × 31.5 cm)

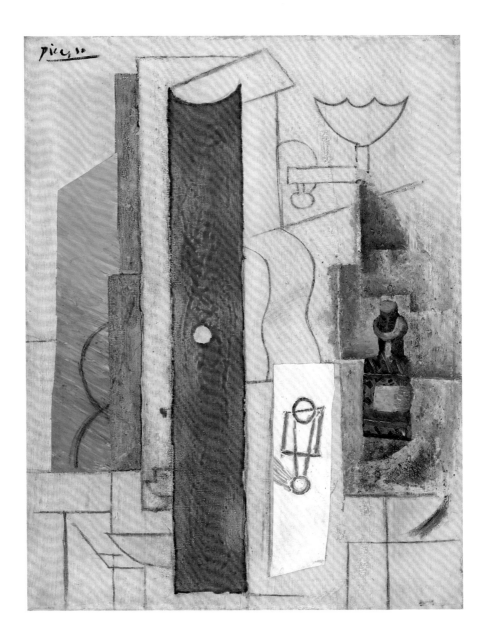

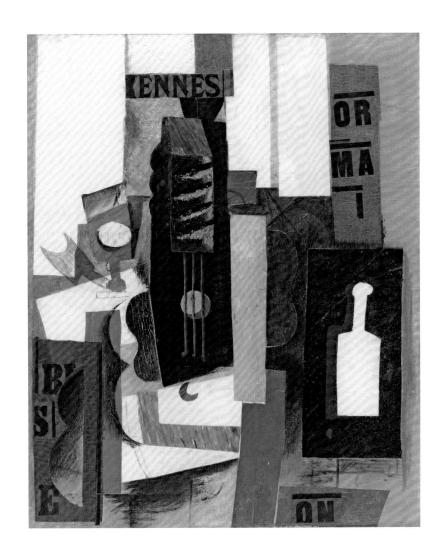

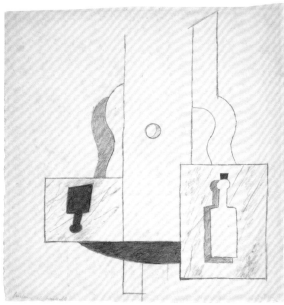

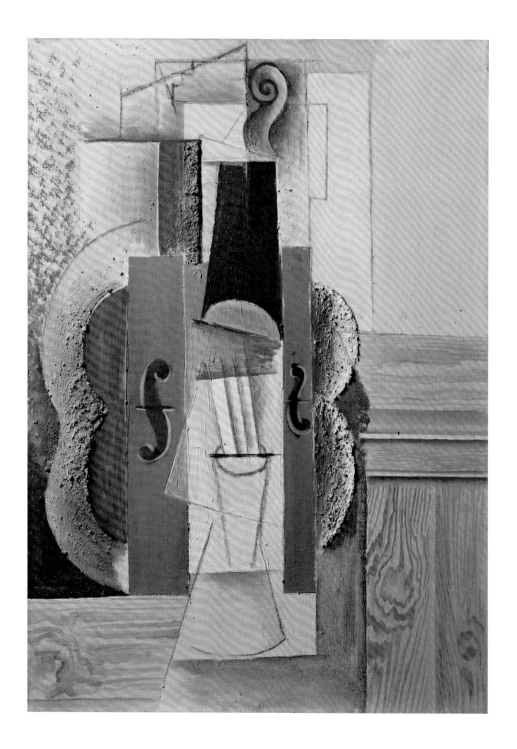

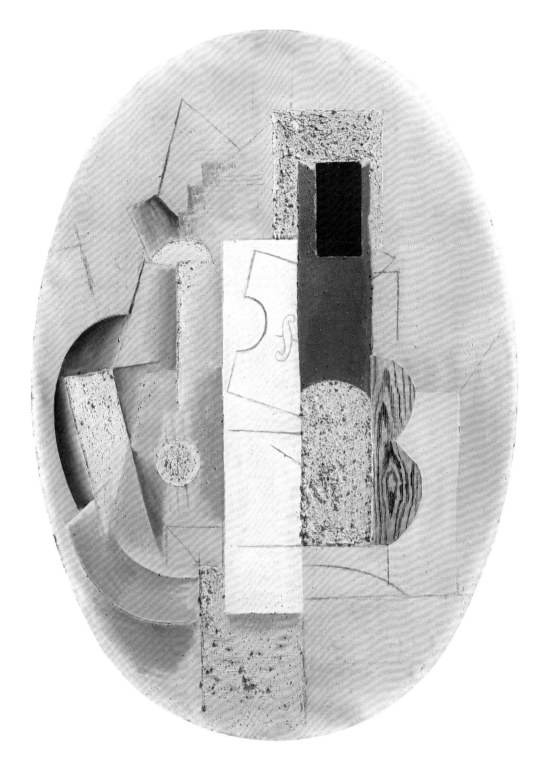

46.

Violin Hanging on the Wall. Possibly begun summer 1912, completed early 1913. Oil, spackle with sand, enamel, and charcoal on canvas, 25 9/16 × 18 1/8" (65 × 46 cm)

47.

Violin and Guitar. Winter 1912–13. Oil, gesso, hand-painted faux bois on cut-and-pasted canvas, charcoal, and granular admixtures on canvas, 36 1/16 × 25 3/8" (91.6 × 64.5 cm)

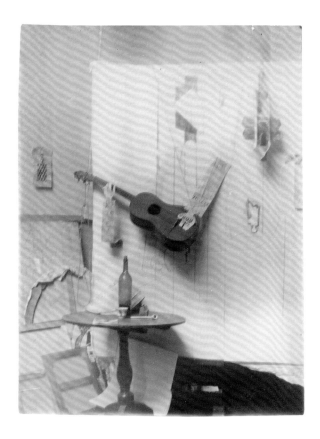

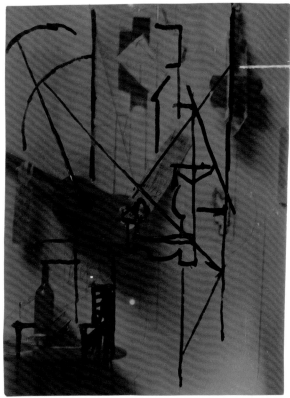

48.

Photographic composition with *Construction with Guitar Player* and *Violin*. On or after January 25 and before March 10, 1913. Gelatin silver print, 4 ¼ × 3 ¼″ (10.8 × 8.2 cm)

49.

Photographic composition with *Construction with Guitar Player* and *Violin*. On or after January 25 and before March 10, 1913. Cropped gelatin silver print with ink, 3 ¹⁄₁₆ × 2 ⁵⁄₁₆″ (7.8 × 5.8 cm)

50.

Photographic composition with *Construction with Guitar Player* and *Violin*. On or after January 25 and before March 10, 1913. Gelatin silver print, 4 ⁵⁄₈ × 3 ⁷⁄₁₆″ (11.8 × 8.7 cm)

51.

Photographic composition with *Construction with Guitar Player*. On or after January 25 and before March 10, 1913. Masked gelatin silver print, 4 ½ × 3 ⁷⁄₁₆″ (11.4 x 8.8 cm)

52.

Photographic composition with *Construction with Guitar Player*. On or after January 25 and before March 10, 1913. Masked gelatin silver print, 4 ⁵⁄₁₆ × 3 ⁹⁄₁₆″ (11 × 9 cm).

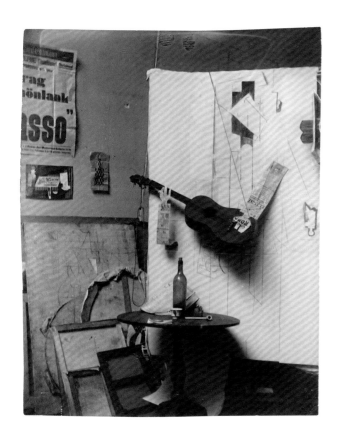

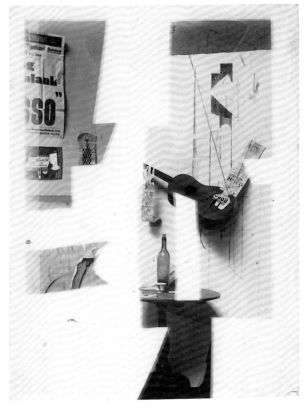

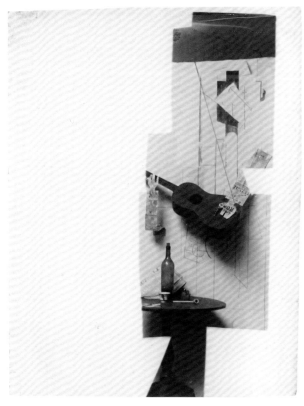

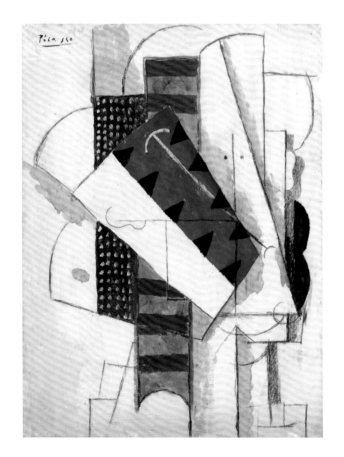

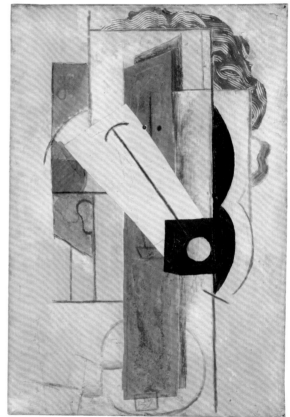

53.

Head of a Man. Early 1913.
Oil, gouache, varnish,
ink, charcoal, and pencil
on paper, 24 ¼ × 18 ¼"
(61.6 × 46.4 cm)

54.

Head of a Girl. Early
1913. Oil and charcoal on
canvas, 21 ⅝ × 14 ¹⁵⁄₁₆"
(55 × 38 cm)

55.

Figure. Spring 1913.
Charcoal on cut paper,
22 ¹³⁄₁₆ × 11 ¹³⁄₁₆"
(58 × 30 cm)

56.

*Head of a Man with a
Moustache.* May 6, 1913,
or later. Ink, charcoal,
and pencil on
newspaper, 21 ⅞ × 14 ¾"
(55.5 × 37.4 cm)

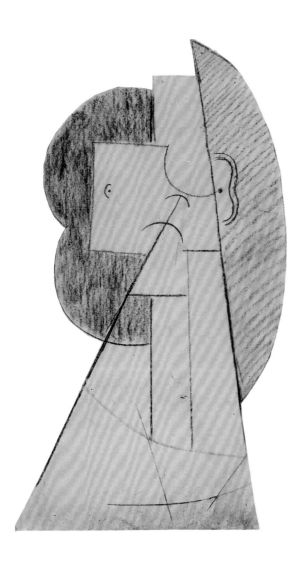

57.
Study for a Construction.
1912. Ink on paper,
6 ¾ × 5″ (17.1 × 12.7 cm)

58.
Study for a Construction.
1912. Ink on paper,
6 ¾ × 5″ (17.1 × 12.7 cm)

59.
*Guitar Player (Study for a
Construction).* 1912.
Ink on paper, 8 ¼ × 5 ⅛″
(21 × 13 cm)

60–68.
Sketchbook. Spring–
summer 1913. 77 pages
with 102 drawings.
Ink and pencil on graph
paper, some pages
with cut-and-pasted
newspaper, colored
paper, or wallpaper,
cover: 5 ½ × 3 %₁₆″
(14 × 9 cm),
sheet: 5 ⁵⁄₁₆ × 3 ⅜″
(13.5 × 8.5 cm)

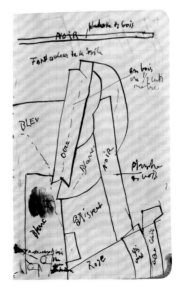

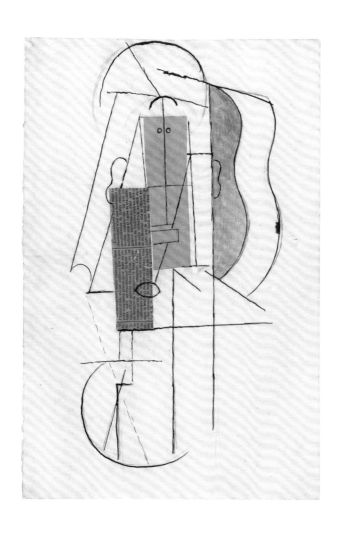

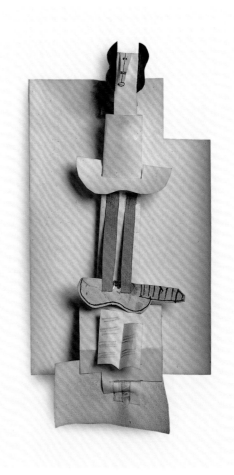

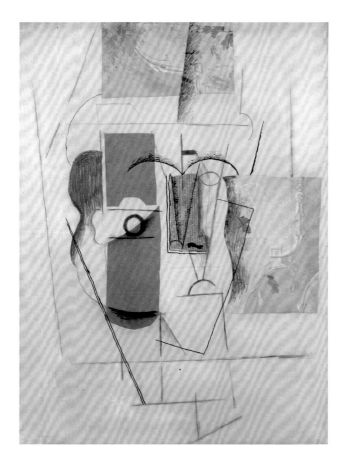

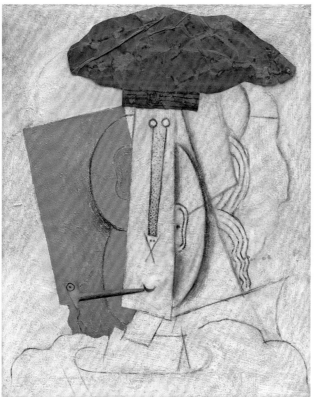

73.

Guitar. Spring 1913.
Cut-and-pasted colored
paper, wallpaper, paper,
and newspaper, charcoal,
and pencil on paper-
board, 17 5/16 × 12 7/8"
(44 × 32.7 cm)

74.

Head. Spring 1913.
Cut-and-pasted colored
paper, gouache, and
charcoal on paper-
board, 17 1/8 × 13"
(43.5 × 33 cm)

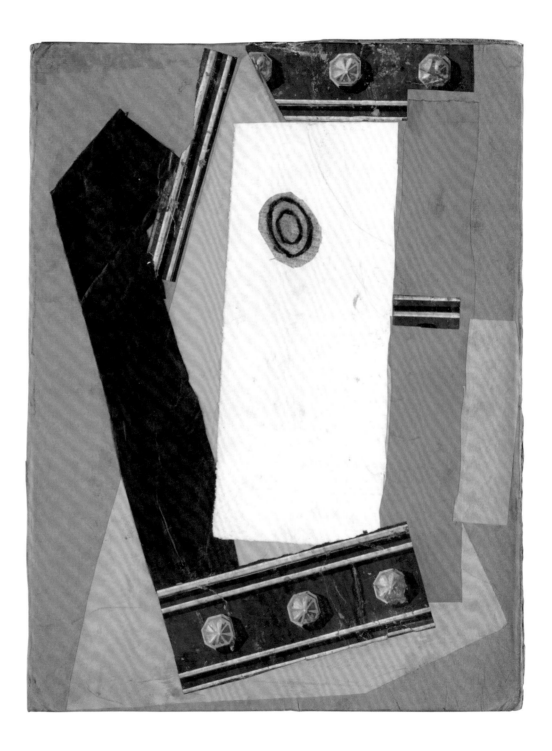

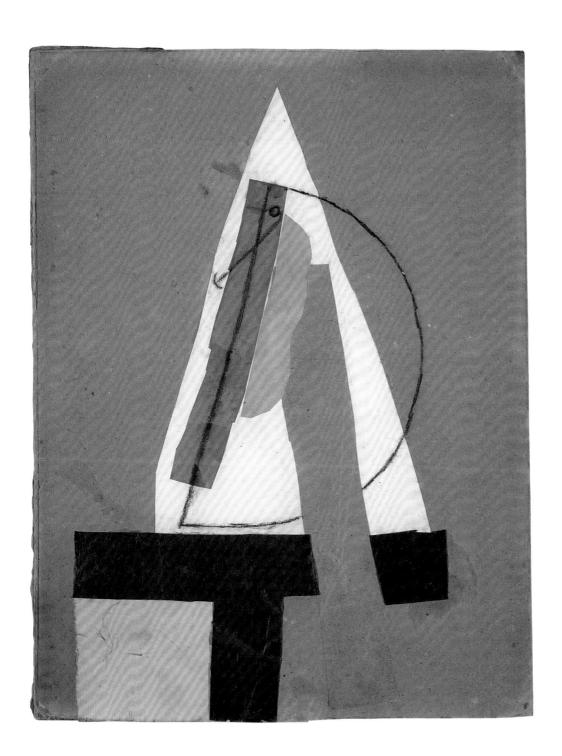

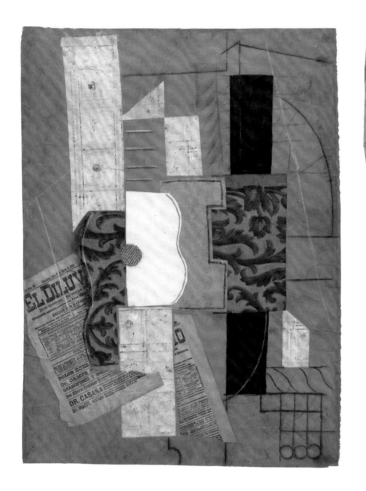

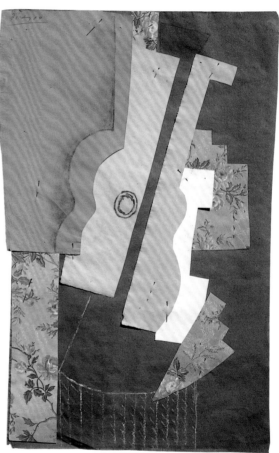

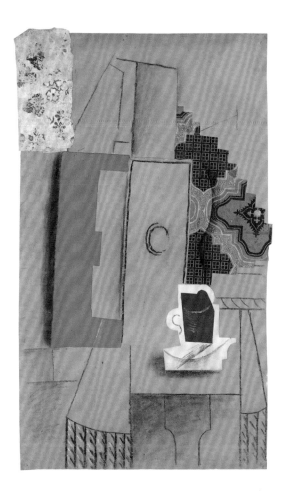

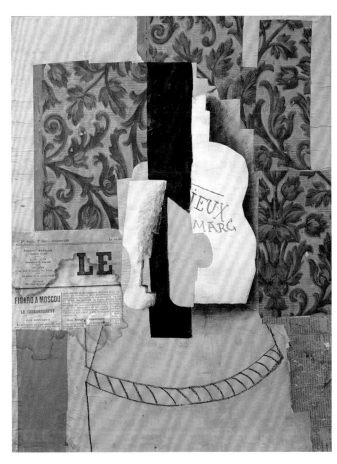

75.

Guitar. March 31, 1913, or later. Cut-and-pasted newspaper, wallpaper, and paper, ink, chalk, charcoal, and pencil on colored paper, 26 ⅛ × 19 ½″ (66.4 × 49.6 cm)

76.

Bar Table with Guitar. Spring 1913. Cut-and-pinned wallpaper and colored paper, and chalk on colored paper, 24 ⅜ × 15 ⅜″ (61.9 × 39.1 cm)

77.

Guitar and Cup of Coffee. Spring 1913. Cut-and-pasted wallpaper and colored paper, charcoal, and chalk on colored paper, 24 ¹³⁄₁₆ × 14 ½″ (63 × 36.9 cm)

78.

Bottle of Vieux Marc, Glass, and Newspaper. Spring 1913. Cut-and-pasted wallpaper, newspaper, and colored paper, ink, and charcoal on paper mounted on canvas, 24 ½ × 18 ⅞″ (62 × 48 cm)

79.

Still life with *Guitar*.
Assembled before
November 15, 1913.
Paperboard, paper,
string, and painted wire
installed with cut
cardboard box, paper,
and wood molding.
Photograph by
Delétang(?) for Galerie
Kahnweiler, Paris.
Published in *Les Soirées
de Paris*, no. 18
(November 15, 1913)

80.

Still life with *Guitar*.
Variant state. Assembled
before November 15, 1913.
Subsequently preserved
by the artist. Paperboard,
paper, string, and
painted wire installed
with cut cardboard box,
guitar: 25 ¾ × 13 x 7 ½"
(65.1 × 33 × 19 cm),
tabletop: 9 ¹⁵⁄₁₆ × 21 ⅜"
(25.2 × 54.3 cm);
overall: 30 × 20 ½ × 7 ¾"
(76.2 × 52.1 × 19.7 cm)

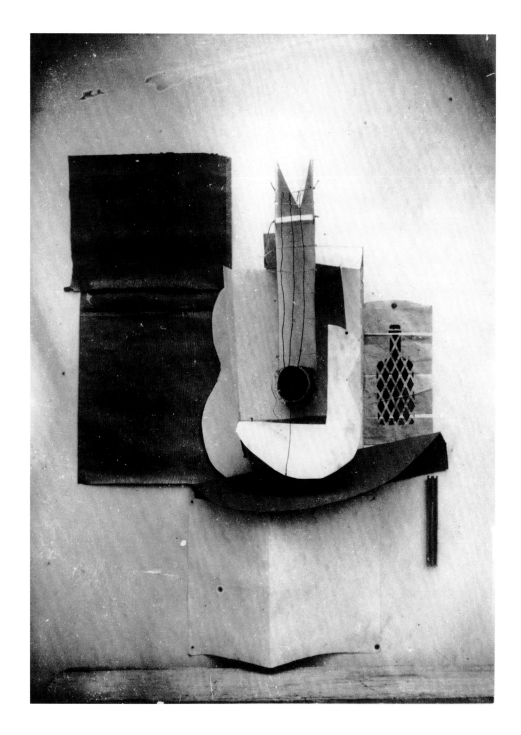

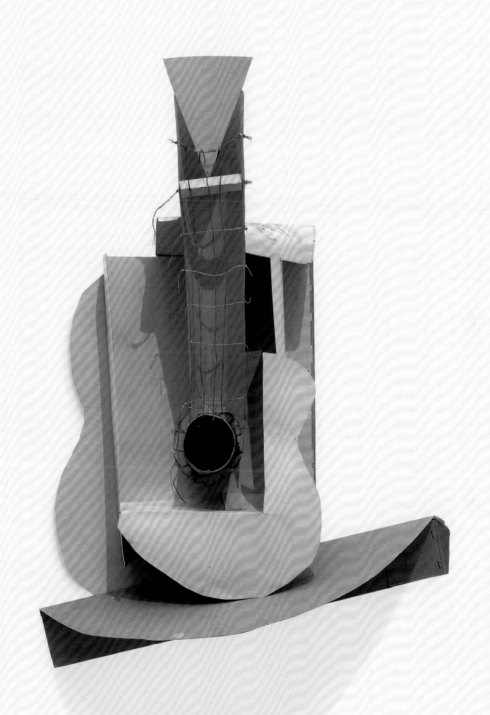

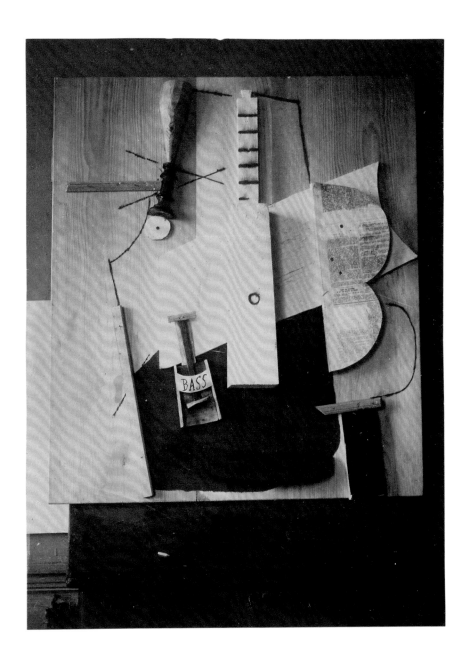

81.

Guitar and Bottle of Bass.
On or after April 23
and before November 15,
1913. Wood, oil, charcoal,
cut-and-pasted news-
paper, and nails on
wood. Photograph by
Delétang(?) for Galerie
Kahnweiler, Paris.
Published in *Les Soirées
de Paris*, no. 18
(November 15, 1913)

82.

Guitar and Bottle of Bass.
Variant state. On or
after April 23 and before
November 15, 1913.
Subsequently modified.
Wood, oil, charcoal,
cut-and-pasted news-
paper, and nails on wood,
35 ¼ × 31 ½ × 5 ½"
(89.5 × 80 × 14 cm)

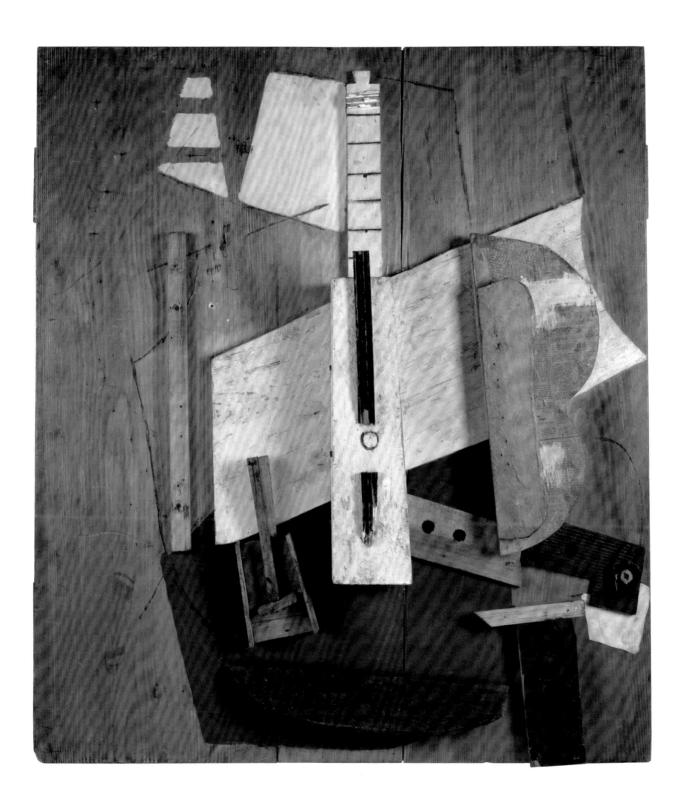

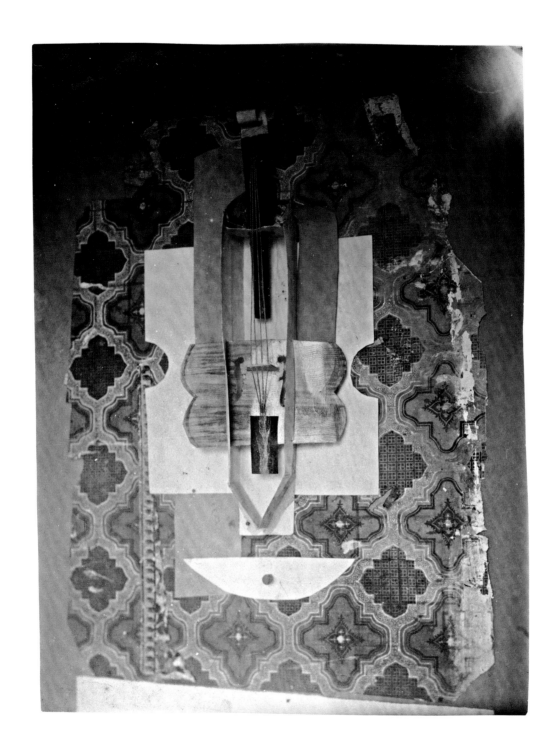

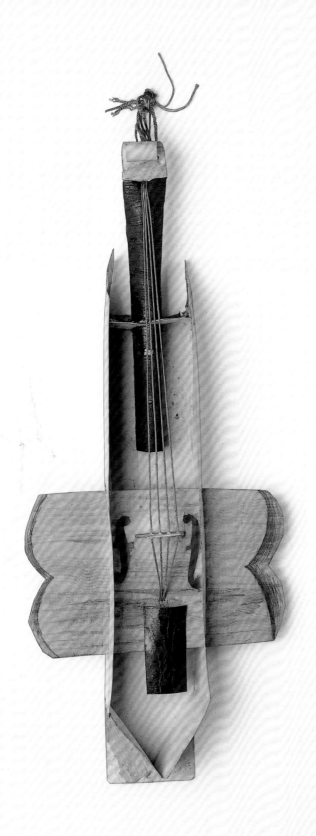

83.

Still life with *Violin.*
Assembled before
November 15, 1913.
Paperboard, ink, water-
color, pencil, and
string, installed with
torn wallpaper,
cut-and-pasted colored
paper, and paper.
Photograph by
Delétang(?) for Galerie
Kahnweiler, Paris.
Published in *Les Soirées
de Paris*, no. 18
(November 15, 1913)

84.

Violin. Winter 1912–13.
Paperboard, ink, water-
color, pencil, and string,
23 1/16 × 8 1/4 × 2 15/16"
(58.5 × 21 × 7.5 cm)

85.

Guitar. After mid-January 1914. Ferrous sheet metal and wire, 30 ½ × 13 ¾ × 7 ⅝" (77.5 × 35 × 19.3 cm)

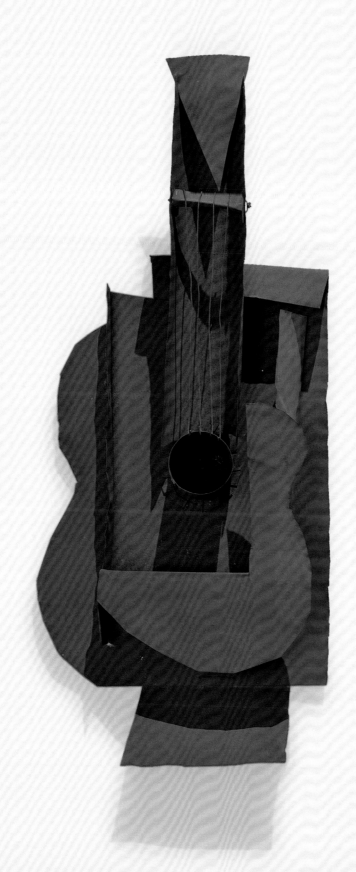

Catalogue

Compiled by Blair Hartzell

Picasso seldom assigned titles to his works. The descriptive titles used here are those established by the key authors identified below and derive from titles used by generations of dealers, collectors, and scholars. English titles are not always a literal translation from the French but rather represent how the works are best known in this language.

The photographs in the catalogue document temporary arrangements of works and ephemeral relief constructions as installed by the artist. Plates 48 to 52 are no longer extant as photographed. Original issues of *Les Soirées de Paris*, in which plates 79, 81, and 83 were first documented, will be included in the exhibition; the artist selectively saved or altered elements of these works. Unless otherwise noted, photographs are thought to be by the artist.

The catalogue raisonné of Picasso's Cubist years by Daix and Rosselet (1979) is the primary reference consulted here for dates and locations. In some instances it is superseded by the revised dating proposed in Rubin 1989 and Karmel 1992. Dating of works is also informed by documentary evidence regarding the artist's location and activities at a given moment, his inscriptions on the work, and the date works entered into the inventory of his dealer, Daniel-Henry Kahnweiler. Whenever a work incorporates or documents a dated piece of newspaper, that date has been indicated as the earliest possible on which the work could have been completed; the artist may have used the newspaper at a later time. Drawings executed on almost exclusively the same paper type and sheet size as works with pasted newspaper, and documented in the studio at the same moment, are proposed to have synchronous dating.

Mediums and dimensions have been provided by the owners or custodians of the works, in some instances augmented by firsthand examination of the works by curators and conservators from The Museum of Modern Art, New York. For the purposes of this catalogue, the term "paperboard" is applied to a range of stiff boards that exhibit finishing steps, such as the paper-faced material Picasso employed in relief constructions and as a support for collage works. "Cardboard" is reserved to describe coarser boards, commonly used for more utilitarian purposes like box making, to which finishing steps have not been applied. "Paper" describes a range of lightweight, thinner, and more flexible material. In measurements, height precedes width, precedes depth. Recto and verso are indicated by the abbreviations R and V, respectively.

Works catalogued in key sources are identified by an abbreviation for the source and the number assigned to the work in that publication. The sources are, in chronological order, Zervos 1932–78 (Z), Daix and Rosselet 1979 (DR), Glimcher and Glimcher 1986 (G), Léal 1996 (L), and Spies 2000 (S). See References, pages 100–2, for full citations.

An asterisk indicates a work not included in the exhibition.

1.

Installation in front of Villa des Clochettes. Sorgues, August or September 1912. Gelatin silver print. 4 ¼ × 3 ⅜" (10.8 × 8.5 cm). Private collection

2.

Guitar. Sorgues, summer 1912. Oil and charcoal on canvas. 25 ⅜ × 19 ¹¹⁄₁₆" (64.5 × 50 cm). Private collection. Z XXVIII 197, DR 488

3.

Guitar. Begun Sorgues, summer 1912, completed Paris, winter 1912–13. Oil and charcoal on canvas. 28 ½ × 23 ⅝" (72.5 × 60 cm). Nasjonalmuseet for kunst, akitektur og design, Oslo. Z II 357, DR 489

4.*

Installation in the artist's studio at 242, boulevard Raspail. Paris, December 4, 1912, or later. Modern print from original glass negative. 3 ⁹⁄₁₆ × 4 ¾" (9 × 12 cm). Archives Picasso. Musée national Picasso, Paris

5.

Installation in the artist's studio at 242, boulevard Raspail. Paris, December 9, 1912, or later. Gelatin silver print. 3 ⅜ × 4 ½" (8.6 × 11.5 cm). Private collection

6.

Installation in the artist's studio at 242, boulevard Raspail. Paris, December 9 or 14, 1912, or later. Gelatin silver print. 3 ⅜ × 4 ¹¹⁄₁₆" (8.6 × 11.9 cm). Private collection

7.

Guitar and Sheet Music. Paris, autumn 1912. Cut-and-pasted wallpaper and sheet music, pastel, and charcoal on paperboard. 22 ¹³⁄₁₆ × 24" (58 × 61 cm). Private collection. Z II(2) 372, DR 506

8.

Bottle, Guitar, and Pipe. Paris, autumn 1912. Oil, enamel, sand, and charcoal on canvas. 23 ⅝ × 28 ¾" (60 × 73 cm). Museum Folkwang, Essen. Acquired in 1964 with the support of the State of North Rhine-Westphalia and the Eugen-und-Agnes-von Waldthausen Platzhoff-Museums-Stiftung. Z II(2) 377, DR 510

9.

Guitar on a Table. Paris, autumn 1912. Oil, sand, and charcoal on canvas. 20 ⅛ × 24 ¼" (51.1 × 61.6 cm). Hood Museum of Art, Dartmouth College, Hanover, New Hampshire. Gift of Nelson A. Rockefeller, Class of 1930. Z II(2) 373, DR 509

10.

Guitar on a Table. Paris, December 1912 or later. Cut-and-pasted wallpaper and charcoal on paper. 18 ¾ × 24 ⅝" (47.5 × 62.5 cm). Kerry Stokes Collection, Perth. DR 508

11.

Guitar. Paris, October–December 1912. Paperboard, paper, string, and painted wire. 25 ¾ × 13 × 7 ½" (65.1 × 33 × 19 cm). The Museum of Modern Art, New York. Gift of the artist. S 27A

12.*

Guitar. Paris, December 3, 1912, or later. Paperboard, cut-and-pasted newspaper, colored paper, and canvas, string, ink, and pencil. 13 × 7 ¹⁄₁₆ × 3 ¾" (33 × 18 × 9.5 cm). Musée national Picasso, Paris. Dation Pablo Picasso, 1979. Z II(2) 770, DR 555, S 30

13.*

Guitar. Paris, December 3, 1912, or later. Paperboard, cut-and-pasted newspaper, and canvas, string, and pencil. 8 ¹¹⁄₁₆ × 5 ¹¹⁄₁₆ × 2 ¾" (22 × 14.5 × 7 cm). Musée national Picasso, Paris. Dation Pablo Picasso, 1979. Z II(2) 779, DR 556, S 29

14.

Guitar, Sheet Music, and Glass. Paris, November 18, 1912, or later. Cut-and-pasted wallpaper, newspaper, sheet music, colored paper, paper, and hand-painted faux bois paper, charcoal, and gouache on paperboard. 18 ⅞ × 14 ⅜" (47.9 × 36.5 cm). McNay Art Museum, San Antonio. Bequest of Marion Koogler McNay. Z II(2) 423, DR 513

15.

Newspaper and Violin. Paris, December 1, 1912, or later. Cut-and-pasted newspaper, colored paper, paper, and hand-painted faux bois paper, charcoal, ink, pencil, and chalk on paperboard. 18 ¹¹⁄₁₆ × 11 ³⁄₁₆" (47.5 × 28.4 cm). Museum Ludwig, Cologne. Z II(2) 417, DR 526

16.*

Violin. Paris, autumn–winter 1912. Cut-and-pasted paper inside folded-and-pasted paper with charcoal. 12 ⅜ × 9 ¼" (31.5 × 23.5 cm). Musée national Picasso, Paris. Dation Pablo Picasso, 1979. Z XXVIII 243, DR 531. Work is reproduced here as viewed through transmitted light.

17.*

Violin and Sheet Music. Paris, autumn 1912. Cut-and-pasted wallpaper, sheet music, and colored paper on cardboard box lid. 30 ¹¹⁄₁₆ × 24 ¹³⁄₁₆" (78 × 63 cm). Private collection. Z II(2) 772, DR 519

18.

Violin. Paris, November 18, 1912, or later. Cut-and-pasted wallpaper, newspaper, colored paper, and paper, ink, charcoal, and pencil on paperboard. 25 ⁹⁄₁₆ × 19 ¹¹⁄₁₆" (65 × 50 cm). Musée national Picasso, Paris. Dation Pablo Picasso, 1979. Z II(2) 774, DR 517

19.

Guitar. Paris, December 1912 or later. Charcoal on paper. 18 ½ × 24 ⅜" (47 × 61.9 cm). The Museum of Modern Art, New York. Gift of Donald B. Marron. Z XXVIII 304

20.

Musical Score and Guitar. Paris, autumn 1912. Cut, pasted, and pinned colored paper, sheet music, and paper, and charcoal on colored paper. 16 ¾ × 18 ⅞" (42.5 × 48 cm). Centre Pompidou, Musée national d'art moderne, Paris. Bequest of Georges Salles, 1967. Z II(2) 416, DR 520

21.

Violin. Paris, autumn 1912. Oil, sand, and charcoal on canvas. 21 ⅝ × 16 ⁵⁄₁₆" (55 × 43 cm). Private collection. Z II(2) 368, DR 515

22.

Violin. Paris, December 1912 or later. Charcoal on paper. 18 ½ × 24 ½" (47 × 62.2 cm). Private collection

23.*

Musical Instruments. Begun Sorgues, summer 1912, completed Paris, early 1913. Enamel, oil, gesso, sawdust, and charcoal on canvas. 38 ⅝ × 31 ½" (98 × 80 cm). The State Hermitage Museum, St. Petersburg. Z II(2) 438, DR 577

24.

Violin. Paris, December 3, 1912, or later. Cut-and-pasted newspaper and charcoal on paper. 24 ⁷⁄₁₆ × 18 ½" (62 × 47 cm). Centre Pompidou, Musée national d'art moderne, Paris. Gift of Henri Laugier, 1963. Z XXVIII 356, DR 524

25.

Violin. Paris, December 1912 or later. Charcoal on paper. 18 ⅛ × 12 ¹³⁄₁₆" (46 × 32.5 cm). Philadelphia Museum of Art. The Louise and Walter Arensberg Collection, 1950

26.

Siphon, Glass, Newspaper, and Violin. Paris, December 3, 1912, or later. Cut-and-pasted newspaper, hand-painted faux bois paper, and paper, and charcoal on paper. 18 ½ × 24 ⅝" (47 × 62.5 cm). Moderna Museet, Stockholm. Z II(2) 405, DR 528

27.

Bottle and Wineglass. Paris, December 4, 1912, or later. Cut-and-pasted newspaper, charcoal, and pencil on paper. 23 ³⁄₁₆ × 18 ¹⁄₁₆" (58.9 × 45.8 cm). Private collection. Z XXVIII 209, DR 549

28.

Bottle and Wineglass. Paris, December 3, 1912, or later. Cut-and-pasted newspaper, charcoal, and pencil on paper. 24 ⁷⁄₁₆ × 18 ⁹⁄₁₆" (62 × 47.1 cm). The Menil Collection, Houston. Z II(2) 424, DR 543

29.

Bottle and Wineglass. Paris, December 3, 1912, or later. Oil, sand, cut-and-pasted newspaper, charcoal, and pencil on canvas. 21 ¾ × 18 ¼" (55.2 × 46.4 cm). Collection Bruno Bischofberger, Zurich. Z II(2) 433, DR 568

30.

Bottle and Wineglass. Paris, December 4, 1912, or later. Cut-and-pasted newspaper, charcoal, pencil, and cut-and-pasted paper over ink on paper. 24 ½ × 18 ¹¹⁄₁₆" (62.2 × 47.5 cm). Staatsgalerie Stuttgart. Graphische Sammlung. Z XXVIII 203, DR 544

31.

Bottle and Wineglass on a Table. Paris, December 3, 1912, or later. Cut-and-pasted newspaper, ink, charcoal, and pencil on paper. 24 ⅝ × 18 ¾" (62.6 × 47.6 cm). The Metropolitan Museum of Art, New York. The Alfred Stieglitz Collection, 1949. Z II(2) 428, DR 548

32.

Bottle on a Table. Paris, December 8, 1912, or later. Cut-and-pasted newspaper and charcoal on paper. 24 ⁷⁄₁₆ × 18 ¹¹⁄₁₆" (62 × 47.5 cm). Fondation Beyeler, Riehen/Basel. Z XXVIII 204, DR 552

33.

Bottle of Marc de Bourgogne, Wineglass, and Newspaper. Paris, December 9, 1912, or later. Oil, sand, cut-and-pasted newspaper, and charcoal on canvas. 18 ¼ × 15 ⅛" (46.3 × 38.4 cm). Bridgestone Museum of Art, Tokyo. Ishibashi Foundation. Z II(2) 432, DR 567

34.

Bottle, Cup, and Newspaper. Paris, December 4, 1912, or later. Cut-and-pasted newspaper, charcoal, and pencil on paper. 24 ¹³⁄₁₆ × 19 ⁵⁄₁₆" (63 × 49 cm). Museum Folkwang, Essen. Acquired 1961. Z II(2) 397, DR 545

35.

Bottle, Wineglass, and Newspaper on a Table. Paris, December 4, 1912, or later. Cut-and-pasted newspaper, charcoal, and gouache on paper. 24 ⁷⁄₁₆ × 18 ⅞" (62 × 48 cm). Centre Pompidou, Musée national d'art moderne, Paris. Gift of Henri Laugier, 1963. Z II(2) 755, DR 542

36.

Bottle and Violin on a Table. Paris, December 3, 1912, or later. Cut-and-pasted newspaper and charcoal on paper. 24 × 18 ⁵⁄₁₆" (61 × 46.5 cm). New Orleans Museum of Art. Muriel Bultman Francis Collection. Z II(2) 756, DR 553

37.

Composition with a Violin. Paris, December 8, 1912, or later. Cut-and-pasted newspaper, pencil, charcoal, and ink on paper. 24 × 18 ⅜" (61 × 46.7 cm). Private collection

38.

Head of a Man. Paris, December 9, 1912, or later. Cut-and-pasted newspaper and charcoal on paper. 24 ⁷⁄₁₆ × 18 ½" (62 × 47 cm). LaM Lille métropole musée d'art moderne, d'art contemporain, et d'art brut, Villeneuve d'Ascq. Gift of Geneviève and Jean Masurel, 1979. DR 538

39.

Head of a Man. Paris, December 2, 1912, or later. Cut-and-pasted newspaper, colored paper, and hand-painted faux bois paper, and charcoal on paper. 24 ⅝ × 18 ½" (62.5 × 47 cm). Private collection. Z II(2) 365, DR 532

40.

Head of a Man with a Hat. Paris, December 2, 1912, or later. Cut-and-pasted newspaper and colored paper, oil, ink, sand, and charcoal on paper. 25 ⁹⁄₁₆ × 19 ¹¹⁄₁₆" (65 × 50 cm). Centre Pompidou, Musée national d'art moderne, Paris. Gift of Henri Laugier, 1963. Z II(2) 411, DR 533

41.

Head of a Man with a Hat. Paris, December 3, 1912, or later. Cut-and-pasted newspaper and colored paper, ink, charcoal, and crayon on paper. 24 ½ × 18 ⅝" (62.2 × 47.3 cm). The Museum of Modern Art, New York. Purchase. Z II(2) 398, DR 534

42.

Man with a Hat and a Violin. Paris, December 9, 1912, or later. Cut-and-pasted newspaper and charcoal on two joined sheets of paper. 49 × 18 ⅞" (124.5 × 47.9 cm). The Metropolitan Museum of Art, New York. Jacques and Natascha Gelman Collection, 1998. Z II(2) 399, DR 535

43.

Guitar, Gas Jet, and Bottle. Paris, early 1913. Oil, charcoal, tinted varnish, and grit on canvas. 27 ¹¹⁄₁₆ × 21 ¾" (70.4 × 55.3 cm). Scottish National Gallery of Modern Art, Edinburgh. Purchased 1982. Z II(2) 381, DR 565

44.

Glass, Guitar, and Bottle. Paris, early 1913. Oil, cut-and-pasted newspaper, gesso, charcoal, and pencil on canvas. 25 ¾ × 21 ⅛" (65.4 × 53.6 cm). The Museum of Modern Art, New York. The Sidney and Harriet Janis Collection. Z II(2) 419, DR 570

45.

Guitar and Bottle. Paris, December 1912 or later. Pencil on paper. 12 ⅝ × 12 ⅜" (32 × 31.5 cm). National Gallery of Art, Washington, D.C. Gift of Mrs. Sara L. Lepman, 1981. Z VI 1105

46.

Violin Hanging on the Wall. Possibly begun Sorgues, summer 1912, completed Paris, early 1913. Oil, spackle with sand, enamel, and charcoal on canvas. 25 ⁹⁄₁₆ × 18 ⅛" (65 × 46 cm). Kunstmuseum Bern. Hermann and Margrit Rupf Foundation. Z II(2) 371, DR 573

47.*

Violin and Guitar. Paris, winter 1912–13. Oil, gesso, hand-painted faux bois on cut-and-pasted canvas, charcoal, and granular admixtures on canvas. 36 1/16 × 25 3/8" (91.6 × 64.5 cm). Philadelphia Museum of Art. The Louise and Walter Arensberg Collection, 1950. Z II(2) 363, DR 574

48.

Photographic composition with *Construction with Guitar Player* and *Violin*. Paris, on or after January 25 and before March 10, 1913. Gelatin silver print. 4 1/4 × 3 1/4" (10.8 × 8.2 cm). Collection Clark Winter

49.

Photographic composition with *Construction with Guitar Player* and *Violin*. Paris, on or after January 25 and before March 10, 1913. Cropped gelatin silver print with ink. 3 1/16 × 2 5/16" (7.8 × 5.8 cm). Private collection

50.

Photographic composition with *Construction with Guitar Player* and *Violin*. Paris, on or after January 25 and before March 10, 1913. Gelatin silver print. 4 5/8 × 3 7/16" (11.8 × 8.7 cm). Private collection. DR 578, S 28

51.

Photographic composition with *Construction with Guitar Player*. Paris, on or after January 25 and before March 10, 1913. Masked gelatin silver print. 4 1/2 × 3 7/16" (11.4 × 8.8 cm). Private collection

52.*

Photographic composition with *Construction with Guitar Player*. Paris, on or after January 25 and before March 10, 1913. Masked gelatin silver print. 4 5/16 × 3 9/16" (11 × 9 cm) Whereabouts unknown

53.

Head of a Man. Paris, early 1913. Oil, gouache, varnish, ink, charcoal, and pencil on paper. 24 1/4 × 18 1/4" (61.6 × 46.4 cm). The Museum of Modern Art, New York. Richard S. Zeisler Bequest. Z II(2) 431, DR 615

54.

Head of a Girl. Paris, early 1913. Oil and charcoal on canvas. 21 5/8 × 14 15/16" (55 × 38 cm). Centre Pompidou, Musée national d'art moderne, Paris. Gift of Henri Laugier, 1963. Z II(2) 426, DR 590

55.

Figure. Céret, spring 1913. Charcoal on cut paper. 22 13/16 × 11 13/16" (58 × 30 cm). Collection Fundación Almine y Bernard Ruiz-Picasso para el Arte, Madrid. Z XXVIII 318

56.

Head of a Man with a Moustache. Céret, May 6, 1913, or later. Ink, charcoal, and pencil on newspaper. 21 7/8 × 14 3/4" (55.5 × 37.4 cm). Private collection

57.

Study for a Construction. Sorgues or Paris, 1912. Ink on paper. 6 3/4 × 5" (17.1 × 12.7 cm). The Museum of Modern Art, New York. Purchase. Z II 296, Z XXVIII 135

58.

Study for a Construction. Sorgues or Paris, 1912. Ink on paper. 6 3/4 × 5" (17.1 × 12.7 cm). The Museum of Modern Art, New York. Purchase. Z II 296

59.

Guitar Player (Study for a Construction). Sorgues or Paris, 1912. Ink on paper. 8 1/4 × 5 1/8" (21 × 13 cm). Collection Marina Picasso. Courtesy Galerie Krugier & Cie, Geneva. Z XXVIII 128

60–68.*

Sketchbook. Céret, spring–summer 1913. 77 pages with 102 drawings. Ink and pencil on graph paper, some pages with cut-and-pasted newspaper, colored paper, or wallpaper. Cover: 5 1/2 × 3 9/16" (14 × 9 cm), sheet: 5 5/16 × 3 3/8" (13.5 × 8.5 cm). Musée national Picasso, Paris. Dation Pablo Picasso, 1979. G 54, L 17. Selected pages reproduced: 12R, 15R, 16R, 25R, 31V, 43R, 46R, 71R, 75R

69.

Head of a Man. Céret, spring 1913. Cut-and-pasted newspaper and colored paper, pencil, and ink on paper. 17 7/8 × 11 3/8" (42.9 × 28.7 cm). The Museum of Modern Art, New York. The Sidney and Harriet Janis Collection. Z II(2) 403, DR 592

70.*

Guitarist with Sheet Music. Céret, spring 1913. Cut, folded, and pasted colored paper and paper with ink and pencil. 8 11/16 × 4 1/8" (22 × 10.5 cm). Private collection. DR 582, S 31

71.

Head of a Man. Céret, spring 1913. Cut-and-pasted wallpaper, newspaper, and paper, charcoal, ink, and pencil on paper mounted on canvas. 24 5/8 × 18 1/2" (62.5 × 47 cm). Kunsthaus Zürich. Grafische Sammlung. Z II(2) 401, DR 591

72.

Student with a Pipe. Paris, winter 1913–14. Oil, gouache, cut-and-pasted paper, gesso, sand, and charcoal on canvas. 28 3/4 × 23 1/8" (73 × 59.7 cm). The Museum of Modern Art, New York. Nelson A. Rockefeller Bequest. Z II(2) 444, DR 620

73.

Guitar. Céret, spring 1913. Cut-and-pasted colored paper, wallpaper, paper, and newspaper, charcoal, and pencil on paperboard. 17 5/16 × 12 7/8" (44 × 32.7 cm). Musée national Picasso, Paris. Dation Pablo Picasso, 1979. Z XXVIII 301, DR 598

74.

Head. Céret, spring 1913. Cut-and-pasted colored paper, gouache, and charcoal on paperboard. 17 1/8 × 13" (43.5 × 33 cm). Scottish National Gallery of Modern Art, Edinburgh. Purchased with help from The National Heritage Lottery Fund and The Art Fund, 1995. Z II(2) 414, DR 595

75.

Guitar. Céret, March 31, 1913, or later. Cut-and-pasted newspaper, wallpaper, and paper, ink, chalk, charcoal, and pencil on colored paper. 26 1/8 × 19 1/2" (66.4 × 49.6 cm). The Museum of Modern Art, New York. Nelson A. Rockefeller Bequest. Z II 348, DR 608

76.

Bar Table with Guitar. Céret, spring 1913. Cut-and-pinned wallpaper and colored paper, and chalk on colored paper. 24 3/8 × 15 3/8" (61.9 × 39.1 cm). Private collection. Z II(2) 418, DR 601

77.

Guitar and Cup of Coffee. Céret, spring 1913. Cut-and-pasted wallpaper and colored paper, charcoal, and chalk on colored paper. 24 13/16 × 14 1/2" (63 × 36.9 cm). National Gallery of Art, Washington, D.C. Collection Mr. and Mrs. Paul Mellon, 1985. Z II 344, DR 602

78.

Bottle of Vieux Marc, Glass, and Newspaper. Céret, spring 1913. Cut-and-pasted wallpaper, newspaper, and colored paper, ink, and charcoal on paper mounted on canvas. 24 ½ × 18 ⅞" (62 × 48 cm). Kunstsammlung Nordrhein-Westfalen, Düsseldorf. Purchase 1965. Z II 349, DR 605

79.*

Still life with *Guitar.* Paris, assembled before November 15, 1913. Paperboard, paper, string, and painted wire installed with cut cardboard box, paper, and wood molding. Photograph by Delétang(?) for Galerie Kahnweiler, Paris. Published in *Les Soirées de Paris*, no. 18 (November 15, 1913). Archives Picasso. Musée national Picasso, Paris. Z II(2) 577, DR 633, S 48

80.

Still life with *Guitar.* Variant state. Paris, assembled before November 15, 1913. Subsequently preserved by the artist. Paperboard, paper, string, and painted wire installed with cut cardboard box. Guitar: 25 ¾ × 13 × 7 ½" (65.1 × 33 × 19 cm), tabletop: 9 ¹⁵⁄₁₆ × 21 ⅜" (25.2 × 54.3 cm); overall: 30 × 20 ½ × 7 ¾" (76.2 × 52.1 × 19.7 cm). The Museum of Modern Art, New York. Gift of the artist

81.*

Guitar and Bottle of Bass. Céret or Paris, on or after April 23 and before November 15, 1913. Wood, oil, charcoal, cut-and-pasted newspaper, and nails on wood. Photograph by Delétang(?) for Galerie Kahnweiler, Paris. Published in *Les Soirées de Paris*, no. 18 (November 15, 1913). Archives Picasso. Musée national Picasso, Paris. Z II(2) 575, DR 630, S 33a

82.

Guitar and Bottle of Bass. Variant state. Céret or Paris, on or after April 23 and before November 15, 1913. Subsequently modified. Wood, oil, charcoal, cut-and-pasted newspaper, and nails on wood. 35 ¼ × 31 ½ × 5 ½" (89.5 × 80 × 14 cm). Musée national Picasso, Paris. Dation Pablo Picasso, 1979. S 33b

83.*

Still life with *Violin.* Céret or Paris, before November 15, 1913. Paperboard, ink, watercolor, pencil, and string, installed with torn wallpaper, cut-and-pasted colored paper, and paper. Photograph by Delétang(?) for Galerie Kahnweiler, Paris. Published in *Les Soirées de Paris*, no. 18 (November 15, 1913). Archives Picasso. Musée national Picasso, Paris. Z II(2) 576, DR 629a

84.*

Violin. Paris, winter 1912–13. Paperboard, ink, watercolor, pencil, and string. 23 ¹⁄₁₆ × 8 ¼ × 2 ¹⁵⁄₁₆" (58.5 × 21 × 7.5 cm). Staatsgalerie Stuttgart. Purchase 1986. DR 629b, S 35

85.

Guitar. Paris, after mid-January 1914. Ferrous sheet metal and wire. 30 ½ × 13 ¾ × 7 ⅝" (77.5 × 35 × 19.3 cm). The Museum of Modern Art, New York. Gift of the artist. Z II(2) 773, DR 471, S 27

Chronology: 1912–1914

Compiled by Blair Hartzell

This selected chronology contextualizes the objects featured in this catalogue and the exhibition it accompanies, incorporating essential biographical and historical information. As Picasso exhibited almost no new artwork during this period, the impressions of visitors to his studio and published references to his most recent work are essential sources, chronicling his artistic activity and its immediate reception.

1912

September 24

Picasso returns to Paris after spending the summer in the South of France, and settles into a new apartment at 242, boulevard Raspail in Montparnasse with his girlfriend, Eva Gouel, who lives and travels with him from 1912 to 1915. He had seen fellow artist Georges Braque frequently in Sorgues, a suburb of Avignon, during the later part of the summer and had had the opportunity to observe Braque's recent work: paper sculptures, papiers collés, and oil paintings incorporating sand.

September 30

Italian artist Umberto Boccioni publishes "*Manifesto tecnico della scultura futurista*" (*Technical Manifesto of Futurist Sculpture*) in the newspaper *L'Italia*. Dated April 11, his text advocates that artists "destroy the literary and traditional nobility of marble and bronze statues" and that they incorporate glass, wood, cardboard, and iron into their sculptures. The manifesto appears in French on October 6 in the journal *Je dis tout*.

October 1

The Salon d'Automne opens at the Grand Palais in Paris; it runs through November 8. It includes no work by Picasso, who during these years frequently exhibits his older work overseas but does not actively show in France. The Cubist work on display is the topic of considerable debate in the press and in political circles.

October 8

Montenegro declares war on the Ottoman Empire. The First Balkan War begins. It ends eight months later but is swiftly followed by the Second Balkan War, which concludes on August 10 with the signing of the Treaty of Bucharest.

October 9

Picasso writes to Braque, "My dear friend Braque, I am using your latest papery and powdery procedures. I am in the process of imagining a guitar and I am using a bit of dust against our horrible canvas." The "procedures" to which Picasso refers are papier collé, constructed sculpture, and the mixing of sand, sawdust, and other particulate matter with paint. The guitar he mentions is most likely the cardboard construction now in the collection of The Museum of Modern Art, New York (plate 11). (The date of its creation reasonably falls between the writing of this letter and the three mid-December 1912 photographs documenting the finished object hanging in the artist's studio.)

The Salon de la Section d'Or preview opens at Galerie La Boëtie in Paris. Organized by a group of artists and writers, the Section d'Or presents 185 works by more than thirty artists and is the first public exhibition of Cubist collage works, those of artist Juan Gris. Several publications appear in conjunction with the show, including the book *Du "Cubisme"* (*On Cubism*), by Albert Gleizes and Jean Metzinger.

December 2

Picasso's exclusive three-year contract with dealer Daniel-Henry Kahnweiler commences, as formalized in a December 18, 1912, letter from the artist.

December 3

Cubism is debated in the French Chamber of Deputies, and the scandal of the Salon d'Automne is attributed specifically to foreign artists. Deputy Marcel Sembat, a collector of Henri Matisse's work, defends the Cubists during the lengthy parliamentary debate.

By mid-December

Picasso has executed a large number of papiers collés on laid paper with newspaper and charcoal, as well as some on paperboard incorporating newspaper, wallpaper, and colored paper. In three photographs of his studio (plates 4–6), he documents several of the former type that incorporate clippings from early-December issues of the Paris daily newspaper *Le Journal*. The artist hangs some of these papiers collés alongside drawings and the cardboard *Guitar*.

December 23

Picasso is in Céret, in the South of France. He travels to Barcelona, where he spends a few weeks.

1913

January 18

In Berlin, Guillaume Apollinaire delivers a lecture in French, "*La Peinture moderne*" (*Modern Painting*), at Galerie der Sturm. His talk is thought to be the first public discussion of Picasso's recent constructions and papiers collés.

January 21

Picasso returns to Paris.

Between January 25 and March 10

Picasso stages *Construction with Guitar Player*, incorporating his *Violin* (plate 84), and photographs his assemblage in situ (plates 48–52). Visible nearby on the studio wall is *Still Life "Au Bon Marché"* (Museum Ludwig, Cologne; DR 557), which, based on its newspaper elements, must date from on or after January 25. It hangs just below a poster for Picasso's one-man show at Moderne Galerie, Munich, that February. *Guitar* (plate 3), visibly reworked since first photographed in Sorgues (plate 1), is stacked with other paintings against the wall (it is transferred to Kahnweiler around the time of, if not before, Picasso's departure for Céret in early March).

February 20

The text of Apollinaire's January lecture appears as "*Die moderne Malerei*" in the journal *Der Sturm*, announcing,

At times Picasso has renounced ordinary paints to compose relief pictures made of cardboard, or papiers collés; he was guided by a plastic inspiration, and these strange, coarse, and mismatched materials were ennobled because the artist endowed them with his own delicate and strong personality.

By March 10

Picasso leaves Paris for Céret. In letters to Kahnweiler throughout March and April, the artist expresses eagerness to see photographs of his recent works, those he had made available to his dealer prior to departing.

March 17

Apollinaire publishes his book *Les Peintres cubistes* (*The Cubist Painters*). It charts the birth of "today's art" and praises Picasso's use of unconventional materials:

You can paint with whatever you like, with pipes, postage stamps, postcards or playing cards, candelabras, pieces of oilcloth, shirt collars, wallpaper, newspapers. I am satisfied to see the work.... Delicate contrasts, parallel lines, a tradesman's craft, sometimes the object itself, sometimes just a hint.

Early May

Picasso's father, Don José Ruiz y Blasco, falls ill, and Picasso departs for Barcelona to be with him. Don José dies on May 3. Picasso's correspondence with his friends in the weeks that follow, on traditional mourning paper bordered in black, describes his deep sadness and his slow return to work after settling back in Céret by May 9.

June 23

Picasso returns to Paris.

c. July 10–22

Picasso is ill and confined to bed. The news is picked up by several newspapers in Paris. Matisse visits the artist regularly as he convalesces.

August 19

After a brief stay in Céret, where his movements are reported in the press, Picasso returns to Paris and finds a new studio and apartment at 5 *bis*, rue Schoelcher. He moves in early October.

November 15

Under the direction of Apollinaire and Jean Cérusse (pseudonym for the duo of Baroness Hélène d'Oettingen and Serge Jastrebzoff [alias Férat]), the journal *Les Soirées de Paris* publishes five still lifes by Picasso as black-and-white plates interspersed throughout issue 18. The first is an oil painting of spring 1912, *Violin, Wineglass, Pipe, and Anchor* (Národní Galerie, Prague; DR 457). The remaining plates are of more recent work: constructions incorporating elements made by the artist (such as cardboard instruments completed months earlier) along with wallpaper, colored paper, and wood. (Three of these constructions survive in partial or altered form [plates 11/80, 82, and 84], while the fourth is believed to have been destroyed [DR 631]).

The Salon d'Automne opens to the public. It runs through January 5, 1914. Apollinaire writes in his column in the newspaper *L'Intransigeant* that the influence of Cubism "can be keenly felt in almost every room."

1914

Russian art critic Iakov Tugendkhol'd publishes an article in the journal *Apollon* on works by Matisse and Picasso in the collection of the wealthy merchant Sergei Shchukin. He describes Picasso's studio, which he may have visited in late January or February 1913:

In the corner were black idols from the Congo and masks from Dahomey; on the table, a *nature morte* of bottles, scraps of wallpaper, and newspapers; on the walls, strange models of musical instruments that Picasso himself had cut from cardboard... his pieces of wood and marble, plaster and newspaper (I have seen pictures in his studio with bits of newspaper stuck to them) are there for the sake of contrast.

Between January 17 and 21

Gertrude Stein takes Vanessa Bell, Roger Fry, and Molly MacCarthy, of the Bloomsbury Group, to visit Picasso in his rue Schoelcher studio. Later, from London, Vanessa Bell writes to Duncan Grant of the constructions she saw there and mentions the artist's desire to "carry them out in iron," indicating that the sheet metal *Guitar* (plate 85) had almost certainly not yet been constructed.

Between February 20 and 26

Stein takes Grant to Picasso's studio. He plans to return bearing a special gift. Writing to Clive Bell on February 26, he explains,

I promised to take him a roll of old wallpaper which I have found in a cupboard at my hotel and which excited him very much as he makes use of them frequently & finds it difficult to get. He sometimes tears such pieces off the wall.

March 2

The Peau de l'Ours sale, the first major auction of modern art, generates international publicity for the Parisian avant-garde and most specifically for Picasso.

Between April 2 and 15

Vladimir Tatlin visits Picasso's studio. He later recalls seeing a cut-up violin suspended from strings there (possibly plate 83 or 84).

June

Art critic Gustave Coquiot publishes his book *Cubistes, futuristes, passéistes: Essai sur la jeune peinture et la jeune sculpture* (*Cubists, Futurists, Traditionalists: An Essay on New Painting and Sculpture*), in which he praises Picasso's manner of collaging,

real pieces of objects — newspaper, fabric, hair, nail clippings, etc., etc. — and it can be done — so skillful is Picasso! — that he will long remain with no possible imitator in the art of gluing various objects on canvas or on paper.

June 20

In London, Vorticist artist and author Wyndham Lewis publishes the article "Relativism and Picasso's Latest Work" in the journal *Blast*:

(Small structures in cardboard, wood, zinc, glass string, etc., tacked, sown [*sic*] or stuck together is what Picasso has last shown as his.)…They do not seem to possess the necessary physical stamina to survive. You feel the glue will come unstuck and that you would only have to blow with your mouth to shatter them.

June 28

Picasso moves into a rented house at 14, rue Saint-Bernard, Avignon.

Archduke Franz Ferdinand is assassinated in Sarajevo. The outbreak of World War I follows on July 28, as Austria-Hungary declares war on Serbia; Germany declares war on France on August 3. Apollinaire and Braque are among the many in Picasso's circle who join the French military. Picasso, a Spanish citizen, does not.

Late June–mid-November

Picasso remains in Avignon through the summer and into the fall, returning to rue Schoelcher on November 17.

December 9, 1914

An Exhibition of Recent Drawings and Paintings by Picasso and by Braque, organized by Marius de Zayas, opens at Alfred Stieglitz's gallery 291 in New York; it runs through January 11, 1915. Among the works included are plates 25, 31, and 47.

Epilogue

A significant portion of the paintings and works on paper in the present catalogue and exhibition — those in the possession of Kahnweiler, a German national, by summer 1914 — were sequestered by the French government following the outbreak of World War I. They were not seen again until the public sales of Galerie Kahnweiler's sequestered stock at Hôtel Drouot, Paris, in 1921–23.

Gouel, Picasso's girlfriend, spent much of 1915 in the hospital. She died on December 14 of that year, presumably of cancer, though she kept the details of her condition a secret. With the aid of Apollinaire and poet Jean Cocteau, in October 1916 Picasso moved out of the rue Schoelcher apartment and into 22, rue Victor Hugo, in Montrouge, at which time the cardboard *Guitar* was most likely disassembled and packed in an Old England department store box. It was never publicly exhibited during the artist's lifetime.

In 1917 in *Picasso i okrestnosti* (*Picasso and Environs*), the first monograph on Picasso, Russian artist and critic Ivan Aksenov reflected on the artist's materials and methods in the years before World War I:

On a picture he pastes pieces of "marbled" paper and rectangles of an "imitation wood" panel and substitutes newspaper clippings — absolute planes — for penciled lettering on white, sometimes joining them with a few lines of charcoal or chalk. He puts different household trash — pieces of boxes, ink bottles, visiting cards, pieces of cardboard, rules, violin fragments — on wooden panels, ties them all together with string, impales them on nails, and hangs it on the wall; sometimes he calls in a photographer.

The first published reference to the sheet metal *Guitar* appeared in André Salmon's book *La Jeune Sculpture française* (*New French Sculpture*), said to have been finished in 1914 but published after the war, in 1919. Salmon wrote in the final chapter, *El Guitare*, that before seeing Picasso's radical construction he simply "did not know what a new subject could be." The sheet metal *Guitar* was installed in the artist's home in the early 1920s (fig. 7, p. 28) and exhibited to the public for the first time in Paris in 1966, at a retrospective exhibition marking Picasso's eighty-fifth birthday.

Translations from the Russian by Charles Rougle (Dorontchenkov 2009).

References

The following list provides full references for those sources cited in abbreviation elsewhere in the book. Relevant archival sources are included in the Notes, pp. 35-39.

Adéma 1968. Adéma, Pierre-Marcel. *Guillaume Apollinaire*. Paris: La Table ronde.

Antliff and Leighten 2008. Antliff, Mark, and Patricia Leighten, eds. *A Cubism Reader, 1906-1914*. Trans. Jane Marie Todd et al. Chicago and London: University of Chicago Press.

Apollinaire 2004. Apollinaire, Guillaume. *The Cubist Painters*. Trans. and commentary by Peter Read. Berkeley and Los Angeles: University of California Press. French ed. 1913.

Baldassari 1994. Baldassari, Anne. *Picasso photographe, 1901-1916*. Paris: Musée national Picasso.

Baldassari 1997. ———. *Picasso and Photography: The Dark Mirror*. Trans. Deke Dusinerre. Paris: Flammarion, and Houston: The Museum of Fine Art.

Baldassari 2000. ———. *Picasso: Working on Paper*. Trans. George Collins. London: Merrell.

Baxandall 1985. Baxandall, Michael. *Patterns of Intention: On the Historical Explanation of Pictures*. New Haven, Conn.: Yale University Press.

Bell 1993. Bell, Vanessa. *Selected Letters of Vanessa Bell*. Ed. Regina Marler. New York: Pantheon Books.

Bois 1990. Bois, Yve-Alain. "Kahnweiler's Lesson." In *Painting as Model*, pp. 65-97. Cambridge, Mass.: MIT Press.

Bois 1992. ———. "The Semiology of Cubism." In Zelevansky 1992, pp. 169-208.

Breton 1972. Breton, André. "Picasso in His Element." French pub. 1933. In *Surrealism and Painting*, pp. 101-14. Trans. Simon Watson Taylor. New York: Icon Editions.

Cabanne 1992. Cabanne, Pierre. *Le Siècle de Picasso*. 4 vols. Paris: Éditions Gallimard. First ed. 1975.

Caizergues and Seckel 1992. Caizergues, Pierre, and Hélène Seckel, eds. *Picasso/Apollinaire: Correspondance*. Paris: Éditions Gallimard and Réunion des musées nationaux.

Clark 1999. Clark, T. J. *Farewell to an Idea: Episodes from a History of Modernism*. New Haven, Conn., and London: Yale University Press.

Cocteau 1923. Cocteau, Jean. *Picasso*. Paris: Delamain, Boutelleau, et Cie.

Cooper 1971. Cooper, Douglas. "Calling All Cubiphiles." *New York Times*, April 4, D22.

Cousins 1989. Cousins, Judith, with Pierre Daix. "Documentary Chronology." In Rubin 1989, pp. 335-445.

Cousins and Seckel 1988. Cousins, Judith, and Hélène Seckel. "*Éléments pour une chronologie de l'histoire des Demoiselles d'Avignon*." In *Les Demoiselles d'Avignon*. Vol. 2, pp. 548-622. Paris: Éditions de la Réunion des musées nationaux. English ed. 1994.

Cowling 1995. Cowling, Elizabeth. "The Fine Art of Cutting: Picasso's *Papiers Collés* and Constructions in 1912-14." *Apollo* 142, no. 405 (November): 10-18.

Cowling 2006. ———, ed. *Visiting Picasso: The Notebooks and Letters of Roland Penrose*. London: Thames and Hudson.

Cox 2009. Cox, Neil. *Picasso's "Toys for Adults": Cubism as Surrealism*. The Watson Gordon Lecture 2008. Edinburgh: National Galleries of Scotland and The University of Edinburgh.

Daix and Boudaille 1967. Daix, Pierre, and Georges Boudaille with Joan Rosselet. *Picasso: The Blue and Rose Periods. A Catalogue Raisonné of the Paintings, 1900-1906*. Trans. Phoebe Pool. Greenwich, Conn.: New York Graphic Society. French ed. 1966. Rev. French ed. 1988.

Daix and Rosselet 1979. Daix, Pierre, and Joan Rosselet. *Picasso: The Cubist Years, 1907–1916. A Catalogue Raisonné of the Paintings and Related Works*. Trans. Dorothy S. Blair. London: Thames and Hudson. French ed. 1979.

Décaudin 1965. Décaudin, Michel. *Oeuvres complètes de Guillaume Apollinaire*. 4 vols. Paris: A. Balland et J. Lecat.

Dorontchenkov 2009. Dorontchenkov, Ilia, ed., with Nina Gurianova. *Russian and Soviet Views of Modern Western Art: 1890s to Mid-1930s*. Trans. Charles Rougle. Berkeley: University of California Press.

Eluard 1944. Eluard, Paul. *À Pablo Picasso*. Geneva and Paris: Éditions des Trois collines.

Fry 1988. Fry, Edward. "Picasso, Cubism, and Reflexivity." *Art Journal* 47, no. 4 (Winter): pp. 296–310.

Fry 1972. Fry, Roger. *Letters of Roger Fry*. 2 vols. Ed. Dennys Sutton. New York: Random House.

Glimcher and Glimcher 1986. Glimcher, Arnold B., and Marc Glimcher, eds. *Je suis le cahier: The Sketchbooks of Pablo Picasso*. With E. A. Carmean et al. New York: The Pace Gallery.

González 1936. González, Julio. "Picasso sculpteur." *Cahiers d'art* 2, no. 6–7: 189–91.

Kachur 1993. Kachur, Lewis. "Picasso, Popular Music, and Collage Cubism (1911–1913)." *The Burlington Magazine* 135, no. 1,081 (April): 252–60.

Kahnweiler 1949. Kahnweiler, Daniel-Henry. *The Sculptures of Picasso*. London: Rodney Phillips & Co. French ed. 1949.

Karmel 1992. Karmel, Pepe. "Appendix 2: Notes on the Dating of Works." In Zelevansky 1992, pp. 322–40.

Karmel 1997. ———, et al. *Picasso: Dessins et papiers collés. Céret 1911–1913*. Céret, France: Musée d'art moderne de Céret.

Knoedler 1958. Galerie Knoedler with Guy Habasque, ed. *Les Soirées de Paris*. With André Billy. Paris: Galerie Knoedler.

Kramer 1971. Kramer, Hilton. "Pablo Picasso's Audacious 'Guitar.'" *New York Times*, March 21, D21.

Krauss 1992. Krauss, Rosalind. "The Motivation of the Sign." In Zelevansky 1992, pp. 261–86.

Krauss 1998. ———. *The Picasso Papers*. New York: Farrar, Straus, Giroux.

Lahuerta 1996. Lahuerta, Juan José. "Una guitarra cubista." In Juan Pérez de Ayala. *La guitarra: Visiones en la vanguardia*, pp. 45–48. Ed. Laura García Lorca. Granada: Casa-Museo Federico García Lorca.

Laurens 1967. Laurens, Claude. *Henri Laurens*. Berlin: Deutsche Gesellschaft für Bildende Kunst.

Léal 1996. Léal, Brigitte. *Musée Picasso carnets: Catalogue des dessins*. 2 vols. Paris: Éditions de la Réunion des musées nationaux.

Leighten 1989. Leighten, Patricia. *Re-ordering the Universe: Picasso and Anarchism, 1897–1914*. Princeton, N.J.: Princeton University Press.

Madeline 2008. Madeline, Laurence, ed. *Pablo Picasso/Gertrude Stein: Correspondence*. Trans. Lorna Scott Fox. London and New York: Seagull. French ed. 2005.

McShine and Cooke 2007. McShine, Kynaston, and Lynne Cooke. *Richard Serra Sculpture: Forty Years*. New York: The Museum of Modern Art.

Monod-Fontaine 1982. Monod-Fontaine, Isabelle, with E. A. Carmean. *Braque: The Papiers Collés*. With Trinkett Clark, Douglas Cooper, Pierre Daix, Edward F. Fry, and Alvin Martin. Washington, D.C.: National Gallery of Art. French ed. 1982.

Monod-Fontaine 1984. Monod-Fontaine, Isabelle. *Donation Louise et Michel Leiris. Collection Kahnweiler-Leiris*. Paris: Centre Georges Pompidou.

Olivier 2001. Olivier, Fernande. *Loving Picasso: The Private Journal of Fernande Olivier*. Trans. Christine Baker and Michael Raeburn. With Marilynn McCully and John Richardson. New York: Harry N. Abrams. French ed. 1933.

Parigoris 1988. Parigoris, Alexandra. "Les Constructions cubistes dans les 'Soirées de Paris.' Apollinaire, Picasso, et les clichés Kahnweiler." *Revue de l'art* 82: 61–74.

Poggi 1988. Poggi, Christine. "Frames of Reference: 'Table' and 'Tableau' in Picasso's Collages and Constructions." *Art Journal* 47, no. 4 (Winter): 311–22.

Poggi 1992. ———. *In Defiance of Painting: Cubism, Futurism, and the Invention of Collage*. New Haven, Conn., and London: Yale University Press.

Poggi 2010. ———. "Picasso's First Constructed Sculpture: A Tale of Two Guitars." Lecture delivered in conjunction with the exhibition *Picasso and the Avant-Garde in Paris*, Philadelphia Museum of Art, February 26. Version presented at "Cubism Approaching 100" panel discussion, College Art Association, 94th Annual Conference, Museum of Fine Arts, Boston, February 24, 2006.

Raynal 1921. Raynal, Maurice. *Picasso*. 2 vols. Munich: Delphin Verlag.

Read 2008. Read, Peter. *Picasso and Apollinaire: The Persistence of Memory*. Berkeley and Los Angeles: University of Berkeley Press.

Richardson 1996. Richardson, John, with Marilyn McCully. *A Life of Picasso: The Cubist Rebel, 1907–1916*. New York: Alfred A. Knopf.

Richardson 2007. ———. *A Life of Picasso: The Triumphant Years, 1917–1932*. New York: Alfred A. Knopf.

Romero 2008. Romero, Pedro G. "The Sun at Night: Preparatory Notes for Poetics and Politics among Flamenco and Modern Artists. A Paradoxical Place." In Patricia Molins and Pedro G. Romero, eds. *The Spanish Night: Flamenco, Avant-Garde, and Popular Culture 1865–1936*, pp. 49–89. Madrid: Museo Nacional Centro de Arte Reina Sofía.

Rosenblum 1971. Rosenblum, Robert. "Picasso and the Coronation of Alexander III: A Note on the Dating on Some Papiers Collés." *The Burlington Magazine* 113, no. 823 (October): 604–8.

Rosenblum 1973. ———. "Picasso and the Typography of Cubism." In Roland Penrose and John Golding, eds. *Picasso 1881/1973*, pp. 49–75. London: Paul Elek Ltd.

Rowell 1979. Rowell, Margit. *The Planar Dimension: Europe, 1912–1932*. New York: Solomon R. Guggenheim Museum.

Rubin 1972. Rubin, William S. *Picasso in the Collection of The Museum of Modern Art*. New York: The Museum of Modern Art.

Rubin 1974. ———. "Visits with Picasso at Mougins." Interview by Milton Esterow. *ARTnews* 72, no. 6 (Summer): 42–46.

Rubin 1980. ———, ed. *Pablo Picasso: A Retrospective*. With Jane Fluegel. New York: The Museum of Modern Art.

Rubin 1984. ———, ed. *Primitivism in 20th Century Art: Affinity of the Tribal and Modern*. 2 vols. New York: The Museum of Modern Art.

Rubin 1989. ———. *Picasso and Braque: Pioneering Cubism*. New York: The Museum of Modern Art.

Rubin 1996. ———. "Picasso and Portraiture: A Long and Fruitful Friendship." Interview by Jason Kaufman. *The Art Newspaper* 58 (April 1): 24–25.

Rubin 1997. ———. "Prologue." In Beyeler et al. *Foundation Beyeler*, pp. 9–13. Munich: Prestel-Verlag, and Riehen, Switzerland: Foundation Beyeler.

Rubin 2006. ———. "Excerpts from *A Curator's Quest*. Building the Museum of Modern Art's Painting and Sculpture Collection, 1967–1988." *Artforum* 44, no. 9 (May): 257–59, 312–18.

Salmon 1919. Salmon, André. *La Jeune Sculpture française*. Paris: Albert Messein.

Salmon 1945. ———. *Souvenirs sans fin: L'Air de la Butte*. Paris: Éditions de la nouvelle France.

Salmon 1956. ———. *Souvenirs sans fin: Deuxième époque*. Paris: Éditions Gallimard.

Spies 1971. Spies, Werner. "*La Guitare anthropomorphe*." *Revue de l'art* 12: 89–92.

Spies 2000. Spies, Werner, with Christine Piot. *Picasso: The Sculptures*. Trans. Melissa Thorson Hause and Margie Mounier. Osterfildern and Stuttgart: Hatje Cantz. German ed. 1971.

Tabart 2000. Tabart, Marielle. *Brancusi et Duchamp: Regards historiques*. Paris: Centre Pompidou.

Weiss 2003. Weiss, Jeffrey, ed. *Picasso: The Cubist Portraits of Fernande Olivier*. Washington, D.C.: National Gallery of Art.

Zelevansky 1992. Zelevansky, Lynn, ed. *Picasso and Braque: A Symposium*. With Yve-Alain Bois, David Cottington, Pierre Daix, Edward F. Fry, Pepe Karmel, Rosalind Krauss, Theodore Reff, Mark Roskill, et al. New York: The Museum of Modern Art.

Zervos 1932. Zervos, Christian. "*Georges Braque et le développement du cubisme*." *Cahiers d'art* 7, no. 1–2: 13–23.

Zervos 1932–78. ———. *Pablo Picasso*. 33 vols. Paris: Éditions Cahiers d'art.

Zervos 1950. ———. "*Oeuvres et images inédites de la jeunesse de Picasso*." *Cahiers d'art* 25, no. 2: 277–85.

Credits

Courtesy Archives Succession Picasso, Paris: 51 bottom left, 71 right; © 2011 Art Resource, New York/courtesy McNay Art Museum, San Antonio: 50 left, 55; courtesy Bildarchiv Preussischer Kulturbesitz: 55; The Bridgeman Art Library, London: 70, 83 right; © 2011 CNAC/MNAM/ Dist. Réunion des Musées Nationaux/Art Resource, New York: 53, 56, 62 bottom, 65, 74 right; courtesy Fundación Almine y Bernard Ruiz-Picasso, Madrid. All rights reserved: 28; © 2011 cliché Galerie Louise Leiris, Paris/ Réunion des musées nationaux/Art Resource, New York: 84, 86, 88; Kunsthaus Zürich: 79 top; The Metropolitan Museum of Art/Art Resource, New York: 60 right, 67; courtesy Museo del Novecento, Milan: 21 left; Museum Folkwang, Essen: 46 bottom, 62 top; The National Gallery of Art, Washington, D.C.: 69 bottom, 83 left; Objectif 31: 42 bottom, 44 bottom, 45, 72 bottom, 73 top left, bottom left; courtesy Pace/MacGill Gallery, New York: 73 right; Philadelphia Museum of Art: 57 top, 71; © 2011 Private collection: 58 left; Réunion des musées nationaux/Art Resource, New York: 16, 21 right, 22, 25, 44 top, 49 left and right, 51 top left, right, 77 all, 80, 87; Scottish National Gallery of Modern Art, Edinburgh: 68, 81; © 2011 Rheinisches Bildarchiv, Cologne: 50 right; © 2011 Staatsgalerie Stuttgart: 89; courtesy University of Pennsylvania, Philadelphia. Rare Book & Manuscript Library: 32 top and bottom.

Photograph credits

Acorn Photo Agency, Perth: 47 bottom; Michele Bellot: 86; Roman Beniaminson: 55; Camerarts, Inc.: 58 left; Judy Cooper, New Orleans Museum of Art: 63 left; Beatrice Hatala: 22, 49 left, right, 87; Paul Hester: 58 right; Bob Kolbrener: 82 right; Jacques Lathion, Nasjonalmuseet for kunst, arkitektur og design: 43; Hervé Lewandowski: 51 right, 80; Fraser Marr: 54 top; Moderna Museet, Stockholm: 57 bottom; Bonnie Morrison: 54 bottom; The Museum of Modern Art, New York, Department of Imaging Services, Robert Gerhardt: 72 top, Thomas Griesel: 18, 76 top left, top right, Kate Keller: 66, Jonathan Muzikar: 71 left, 82 left, 90, Mali Olatunji: 31, John Wronn: 48, 52, 69 top, 79 bottom, 85; Jeffrey Nintzel: 47 top; R. G. Ojeda: 21 right; Jean-Claude Planchet: 74 right; Adam Rzepka: 52 bottom, 65; Peter Schibli, Basel: 61 left; Staatsgalerie Stuttgart: 60 left; Malcom Varon: 67; Peter Willi: 70, 83 right.